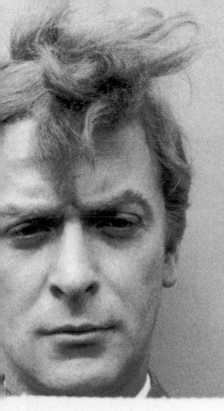

World's
Largest
Evening
Sale

The Evening
and STAR

LONDON, TUESDAY, JULY

No. 25,985.

First Into Room 14 Is
Mr. Gresham Cooke, And
The First Vote Goes Into
The Ballot Box

THE
Is The Tories
Vote Day Mood

By JOHN DICKINSON
Evening News' Political Correspondent

"Evening News nerve-racking suspense
TERRIFIC. the last moments of the
ballot this afternoon as
waited for the result.

Purchase
Threatened

SENTENCED
TO DEATH

CARS
TV, Fridges

michael caine: 1960s

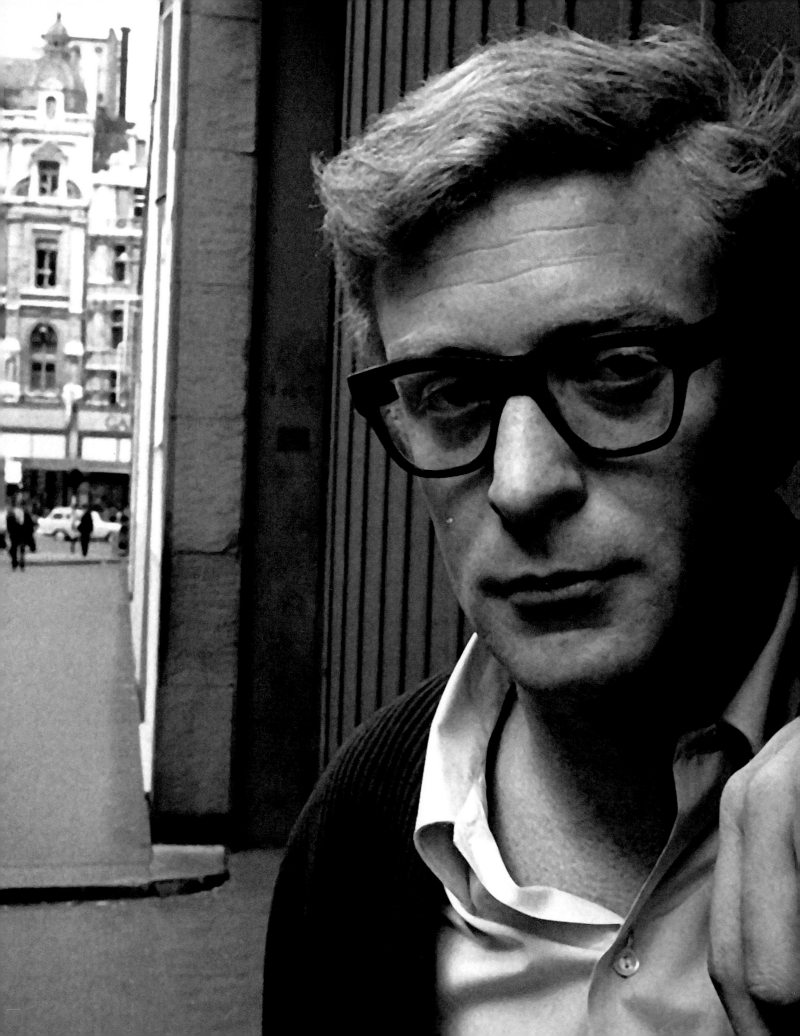

michael caine: 1960s

graham marsh

R|A|P

REEL ART PRESS

Author and Art Director: Graham Marsh
Editor: Tony Nourmand
Page Layouts: Jack Cunningham
Text Editor: Alison Elangasinghe

First published 2013 by Reel Art Press, an imprint of Rare Art Press Ltd., London, UK. www.reelartpress.com

ISBN: 978-0-9572610-9-9

Printed in China.

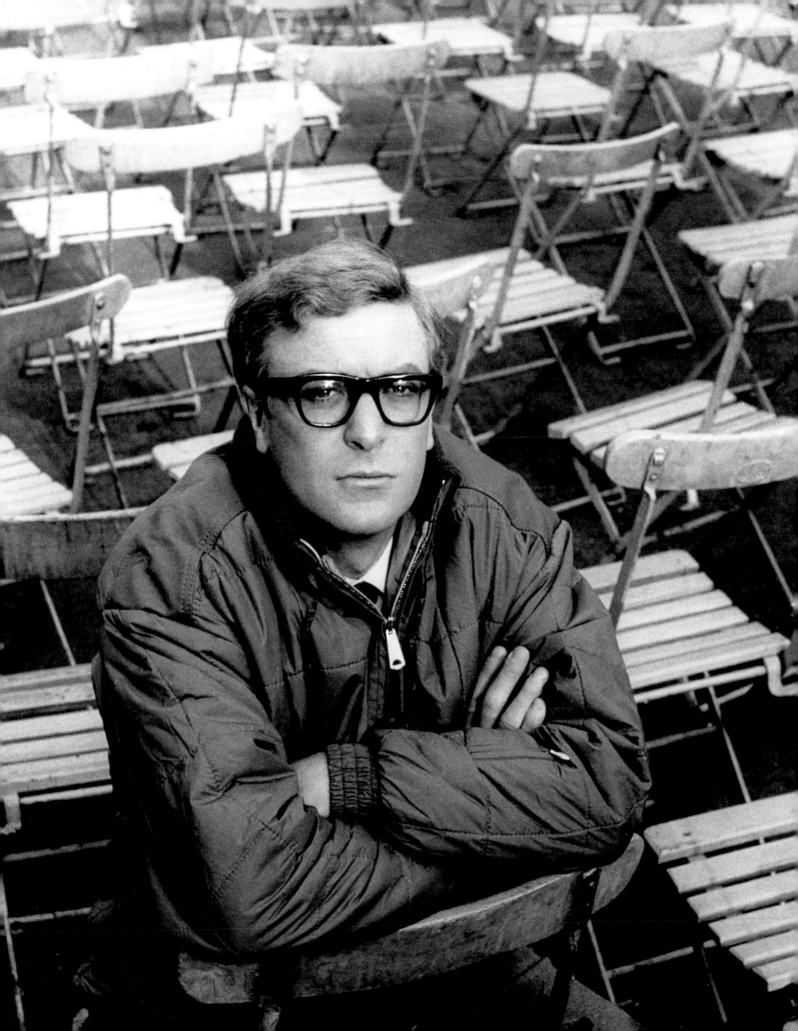

contents

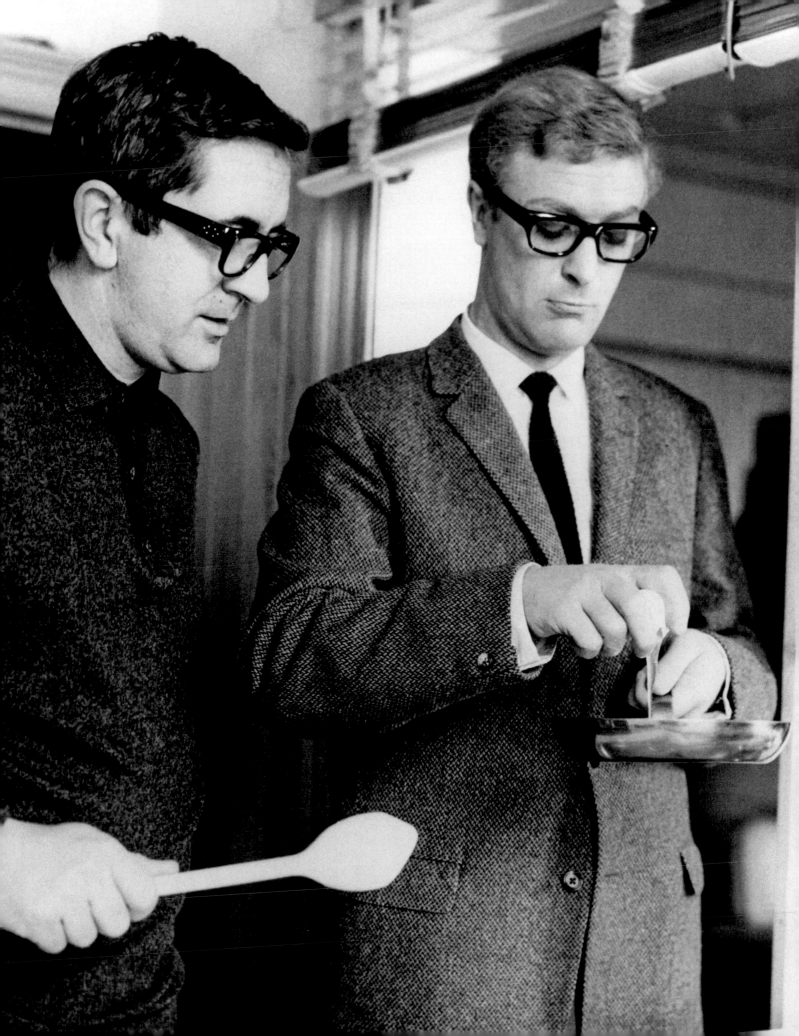

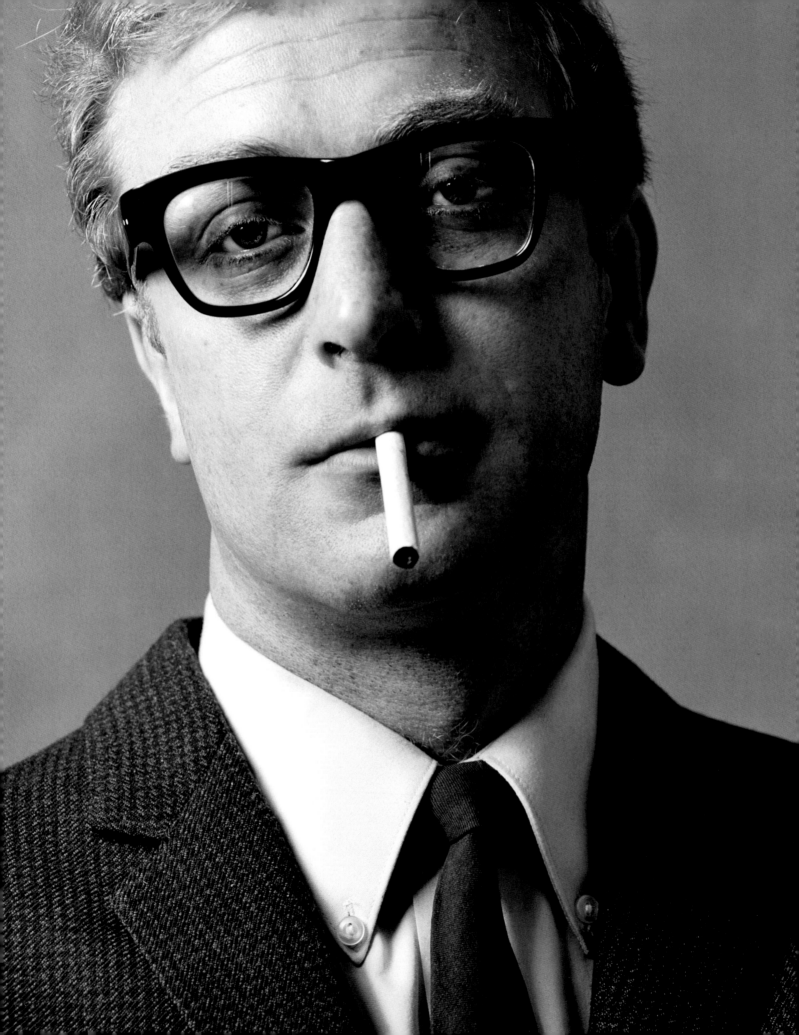

introduction

'the first actor i ever saw was the lone ranger. i thought, that's what i want to do.'

Michael Caine in the 1960s. Michael Caine *was* the 1960s. He was living proof of the old cliché, right place, right time! His movies and the women he dated defined the decade. He was dynamic, witty, working class – the perfect sixties man. He was Harry Palmer, Alfie Elkins and Charlie Croker all rolled into one. He was the very form and model of cool.

In 1960, Michael Caine was 27 years old. It was a good age for a south London boy who had a burning ambition to become a famous, successful actor. Indeed, unbeknown to him, by the decade's close he would be an international movie star. So far, it had been an eventful journey.

Caine was born Maurice Joseph Micklewhite on 14 March 1933 in Rotherhithe, south east London. His mother, Ellen, was a cook and charlady and his father, who had the same name as our hero, was a Billingsgate Fish Market porter. Caine grew up in Southwark, a stone's throw from Rotherhithe. During the Second World War, like a lot of kids who lived in the capital, he was evacuated to the countryside. In his case it was North Runcton in Norfolk. His experiences there were mixed and, being a city boy at heart, this must have been a shock to young Michael's system. There is a line of dialogue from *Alfie* that for Caine surely had an element of truth to it, 'I hate the country, how can you rest with all that bleeding dawn chorus?'

When the war finally ended and his father was demobolised, the family was rehoused by the council in Marshall Gardens at the Elephant and Castle in south London. Home was a prefabricated house, whose components were made in Canada as much of London's housing stock had been damaged during the Blitz in 1940, courtesy of the German Luftwaffe. As Caine said of that period, 'The prefabs, as they were known, were intended to be temporary homes while London was rebuilt, but we ended up living there for 18 years and for us, after a cramped flat with an outside toilet, it was a luxury.'

In order to get to the other side of the tracks, Caine figured early on that a good education was essential for a bright working-class lad. He proceeded to immerse himself in books that provided information needed to pass the eleven-plus exam, which he did in 1944. Any spare time he had was spent at Saturday morning pictures watching Lone Ranger flicks. When he left grammar school aged 16, he had a school certificate in six subjects under his belt.

The film producer Jay Lewis, who had offices in Soho's Wardour Street, employed Caine briefly as a filing clerk and messenger. 'Starring Maurice Micklewhite...' Hmmm, the name needed working on but the seed of acting was sown. However, his daydreams were rudely interrupted when Her Majesty the Queen requested that he join her army. He agreed and served in the British Army's Royal Fusiliers, first in Germany then on active service during the Korean War. When he returned to Civvy Street Mickelwhite, as he still was, became an actor. All those years watching the Lone Ranger at the cinema were going to pay off.

Michael Scott was the moniker Caine adopted for his stage name, until his agent informed him that there was already an actor with that name and that he had better come up with an alternative immediately. Talking to his agent from a telephone box in Leicester Square, London, he scanned the square for inspiration. *The Caine Mutiny,*

'in england I was a cockney actor. in america, i was an actor.'

starring Humphrey Bogart, was playing at the Odeon cinema. That was it – Bogart was his favourite actor so he decided to change his name to 'Michael Caine'. On many chat shows and interviews that followed Caine has joked that had he looked the other way, he would have ended up as 'Michael *One Hundred and One Dalmations*'.

After his tour of duty at the various repertory companies at the start of his career, Caine's film debut was, ironically, a war movie called *A Hill in Korea*. Not only did he act in it but also, because he had served in Korea, he was enlisted as a technical advisor. This, if nothing else, meant more money, which at the time, for a struggling actor, came in very useful.

Career breaks have a habit of surfacing in the most unexpected ways. They can, however, have you sleeping between silk sheets for the rest of your life. Stanley Baker, Caine's co-star in *A Hill in Korea*, wanted Caine to be in *Zulu*, a film Baker was producing and starring in. The year was 1963. Location shooting for *Zulu* was scheduled at 14 weeks in Natal, South Africa. Michael Caine was on his way. Better lock up your daughters!

Caine's performance as the upper class British Army officer Gonville Bromhead in *Zulu*, one of the best war films of the 1960s, proved somewhat paradoxical, as Caine was to become notable for his cockney accent, rather than the received pronounciation hitherto considered proper for serious actors.

'It was the 1960s – I was in discos every night...' Caine was not alone, with him on most occasions were fellow actor Terence Stamp, tailor Doug Hayward, founder of Annabel's nightclub Mark Birley and Johnny Gold, co-owner with Caine of Tramp, the legendary club in Jermyn Street. Oh yes, and the women. There were always plenty of women to make the evenings interesting. This disparate coterie of friends, this motley crew of hedonists, proceeded to cut a swathe through what became known, according to *Time* magazine, as 'Swinging London'.

Anyway, it was all very well being one of London's most swinging bachelors but it was back to work for Caine, who had just landed a plum role as the star of the movie, *The Ipcress File*. Caine plays Harry Palmer, a reluctant but professional spy who despite his insolent manner is a classical music loving, extremely proficient cook. He can also charm a woman by simply breaking eggs! And as a bonus, the movie has an enigmatic soundtrack by the peerless John Barry. Two other Harry Palmer movies followed, first *A Funeral in Berlin* and then *Billion Dollar Brain*. Neither are a patch on *The Ipcress File* but they are saved by some good locations, sharp clothes, beautiful women and, of course, the laconic Mr Caine.

Alfie and *The Italian Job* were two well-dressed movies thanks to the tailoring skills of one man, Douglas Frederick Cornelius Hayward, known to all as Doug Hayward. He was a good friend of Caine and, like him, was working-class with an unmistakable London accent. Hayward left school at 15 looking for a white-collar job. He would later muse, 'We didn't have a career's master but I found a booklet which listed possible occupations. I went down the list and when

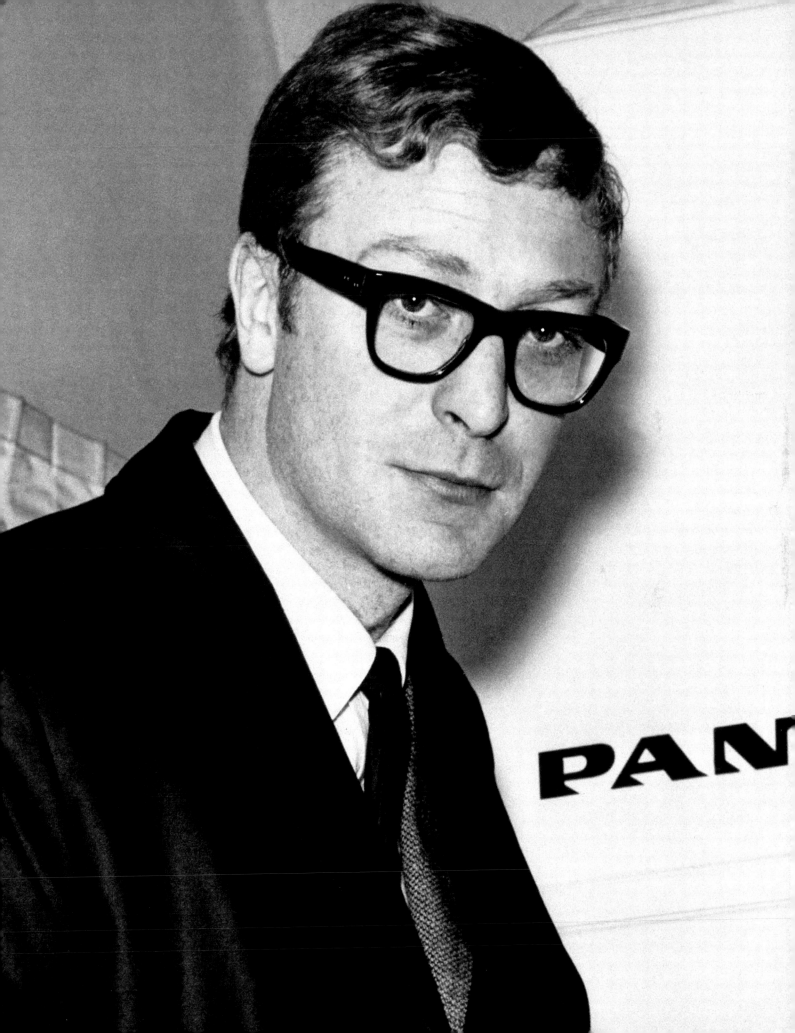

PAN

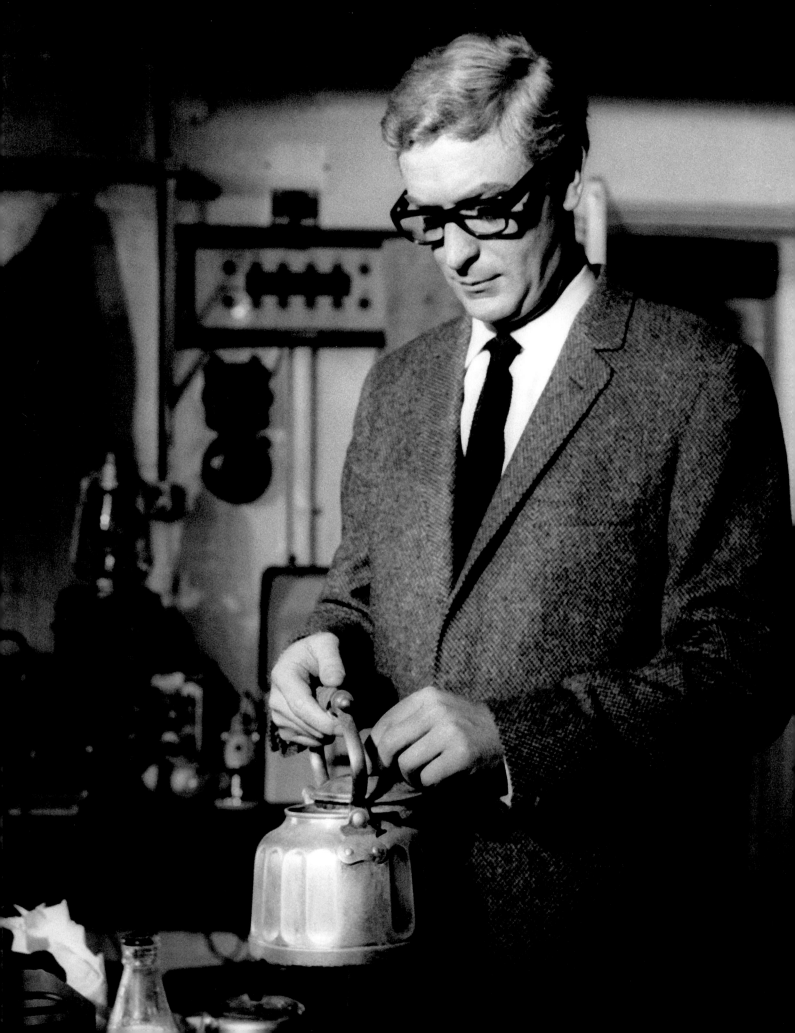

'i've a soft spot for actresses. when i was poor, they were the only people who were nice to me!'

got to T for tailor I thought, I don't know any tailors. I can't ever be judged as being a bad or a good one, so I'll be a tailor.' The suits he made perfectly complemented the sleek, sharp and minimal look that the 'Faces' had nailed down so completely. It was rumoured, probably true, that Hayward, a lifelong womaniser and *bon vivant*, was the real-life inspiration for Caine's screen role as Alfie Elkins.

In the early to mid-1960s clothes played a major part in the lives of the original London Modernists. They had very few heroes outside of the tailors they frequented and the modern jazz, *Atlantic, Stax* and *Motown* musicians that were the required listening. They did, however, make a few exceptions. Of course Mods had continental movie heroes such as Marcello Mastroianni and Jean-Paul Belmondo but there weren't too many homegrown British actors that they admired except for Sean Connery and Michael Caine, the latter being considered an honorary Mod. So it was no surprise to them that *Alfie*, apart from being given the full Swinging London Mod movie treatment, also had a soundtrack by the legendary tenor saxophonist, Sonny Rollins, a solid favourite of those dedicated followers of fashion.

Now, *The Italian Job* is basically a caper film involving the planning and execution of a Turin gold bullion heist. On the scale of things the movie was essentially non-violent as only the cars were killed. Michael Caine plays Charlie Croker, a kind of wide boy, just out to get the money, pull all the beautiful women, get laid and go home. However, it turned out to be the movie that defined the 1960s. Not to everyone's taste but to those in the know, it's a stone cold classic. Subsequent showings on television and releases on DVD have established *The Italian Job* as a British institution.

The movie is literally swathed in the Union Jack from beginning to end. It has every classic British car of the decade – Aston Martin DB4, E-Type Jaguar and three Mini Coopers in red, white and blue. The memorable soundtrack by the seriously hip Quincy Jones featured, bizarrely for an American jazz composer, the very British 'Get a Bloomin' Move On', better known as 'The Self Preservation Society', the lyrics of which consisted of Cockney rhyming slang and was performed by the cast of the movie.

In November 2004, *Total Film* magazine named *The Italian Job* the 27th greatest British film of all time, and the line Caine has in the movie, 'You're only supposed to blow the bloody doors off', was voted favourite film one-liner in a poll of one thousand film fans. Now that the movie has achieved cult status, Michael Caine and *The Italian Job* will be forever inextricably linked, which is no bad thing to have on your report card.

Although Michael Caine can still somehow evoke the London of the 1960s he has, over the years, become an indispensable part of modern British life. His distinctive accent and manner has been endlessly impersonated by a host of comedians but he is, and always will be, the original. Caine remains as popular today as he ever did and as he apparently never said – *'Not many people know that'*...

GRAHAM MARSH

13

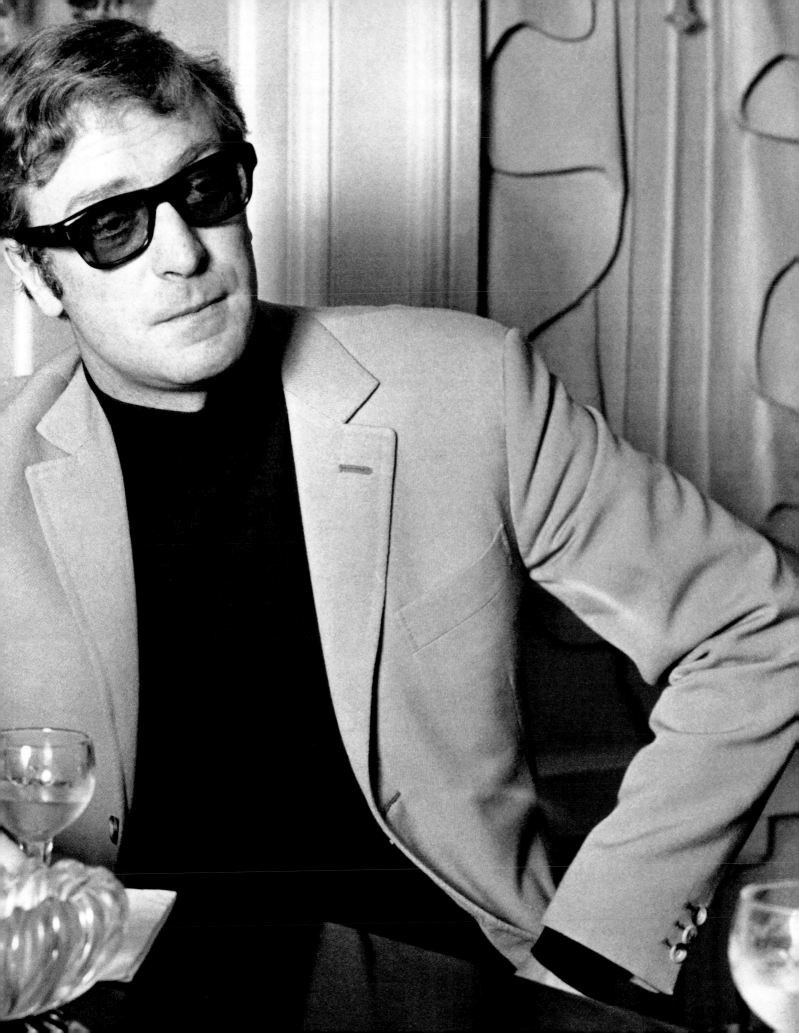

early days...

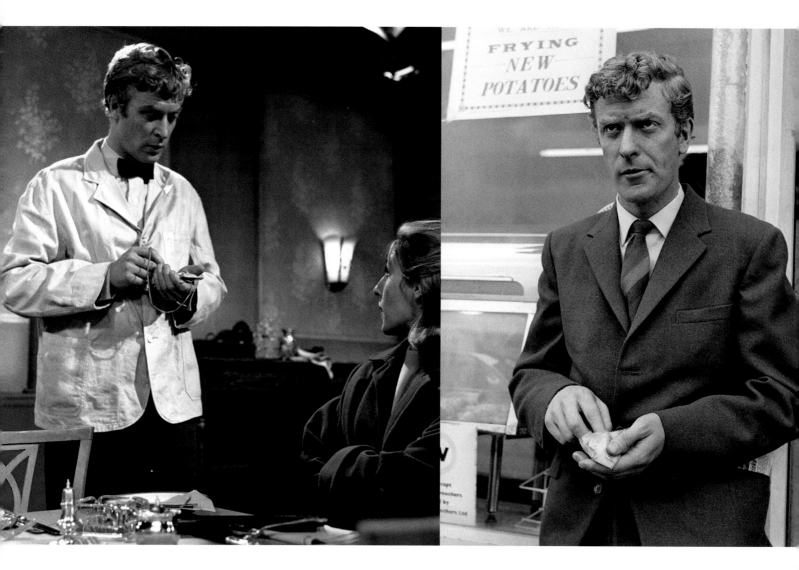

Above: Our man on the box. Two stills from a 1962 one-off
television play called **LUCK OF THE DRAW**. The actress admiring Mr
Caine's white waiter's jacket is Ann Lynn. *Opposite:* Michael Caine's
moody portrait for the 1961 'ITV play of the week', **RING OF TRUTH**.
The question is, where are his spectacles?

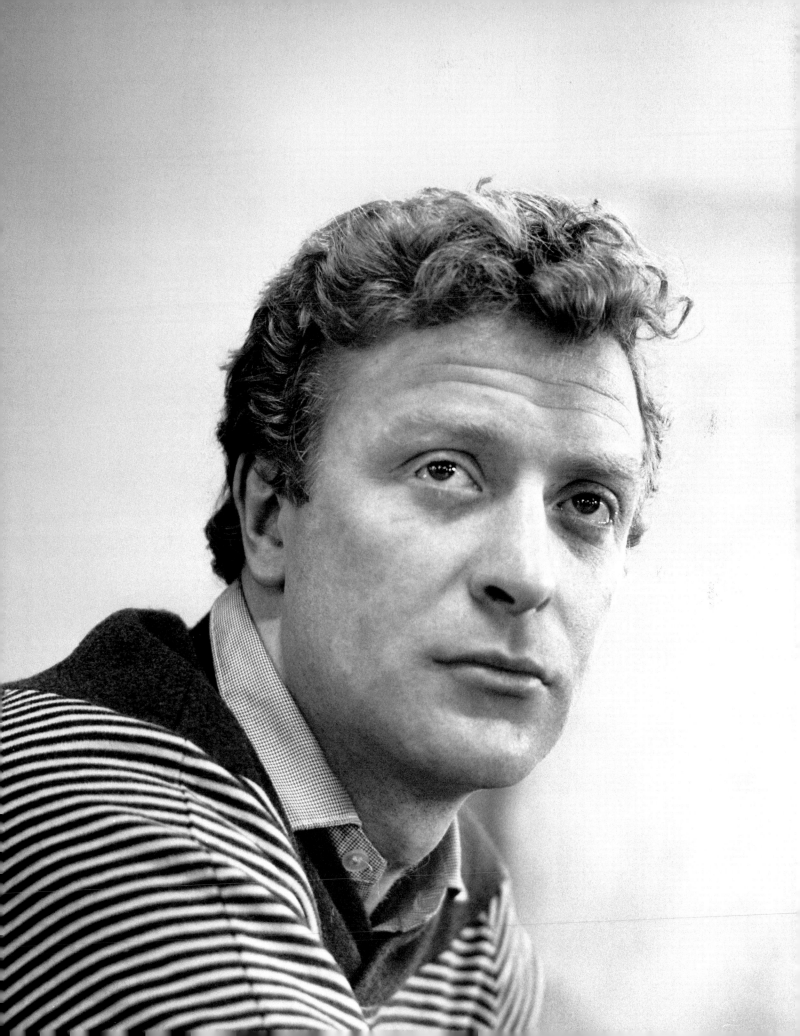

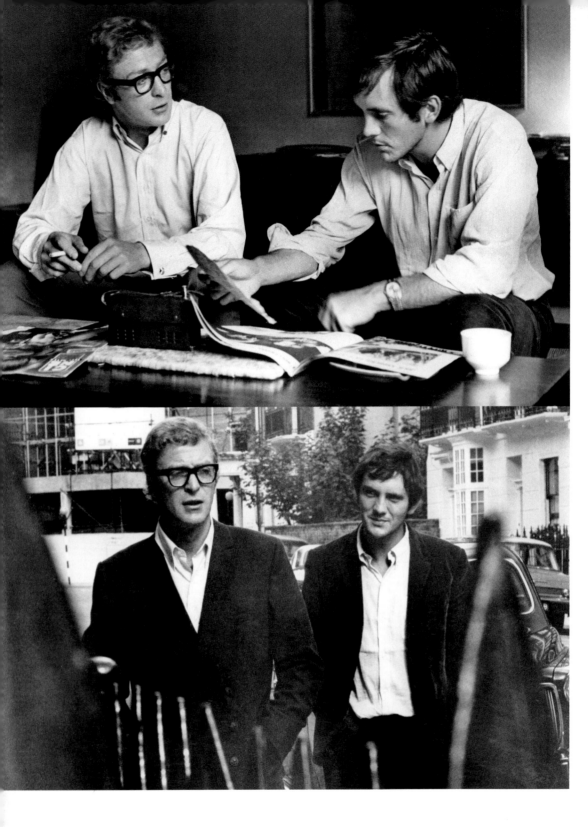

Above: Cockney rebels. A lethal combination, Michael Caine and Terence Stamp suited and booted and wearing their best button-down shirts. Better lock up your daughters … and throw away the key. *Opposite:* Band members of the 1960s group **A BAND OF ANGELS** with (clockwise from top) Michael Caine, Mike d'Abo (the group's leader), Terence Stamp and fellow actor David Warner.

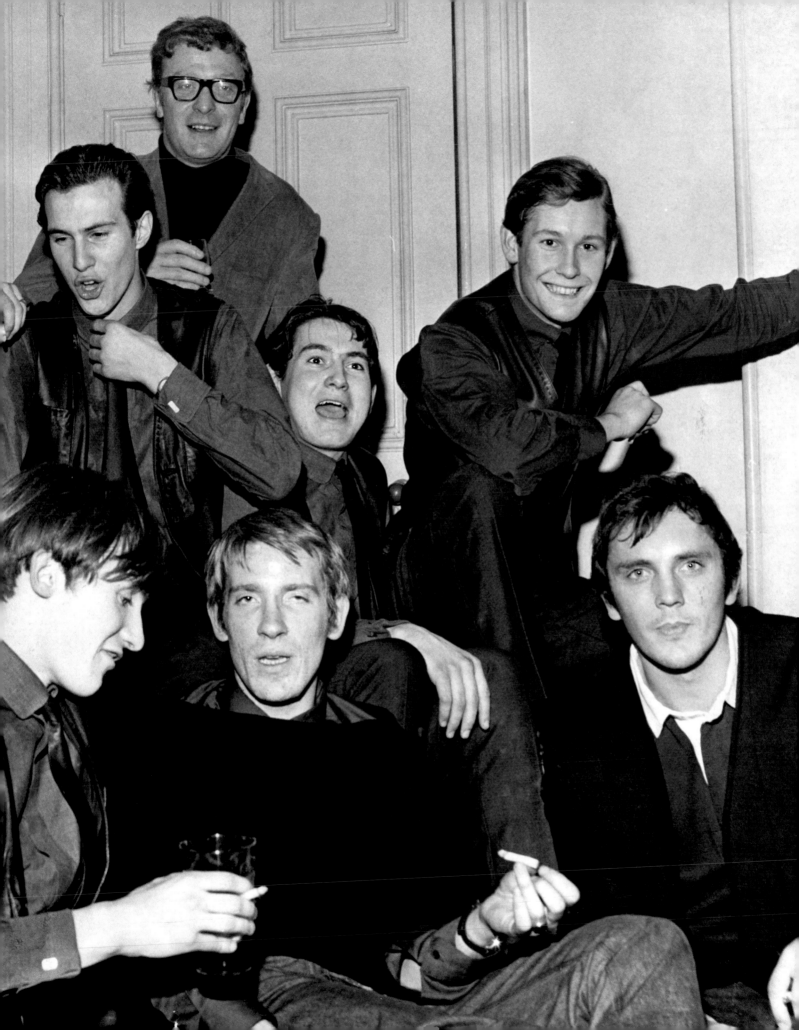

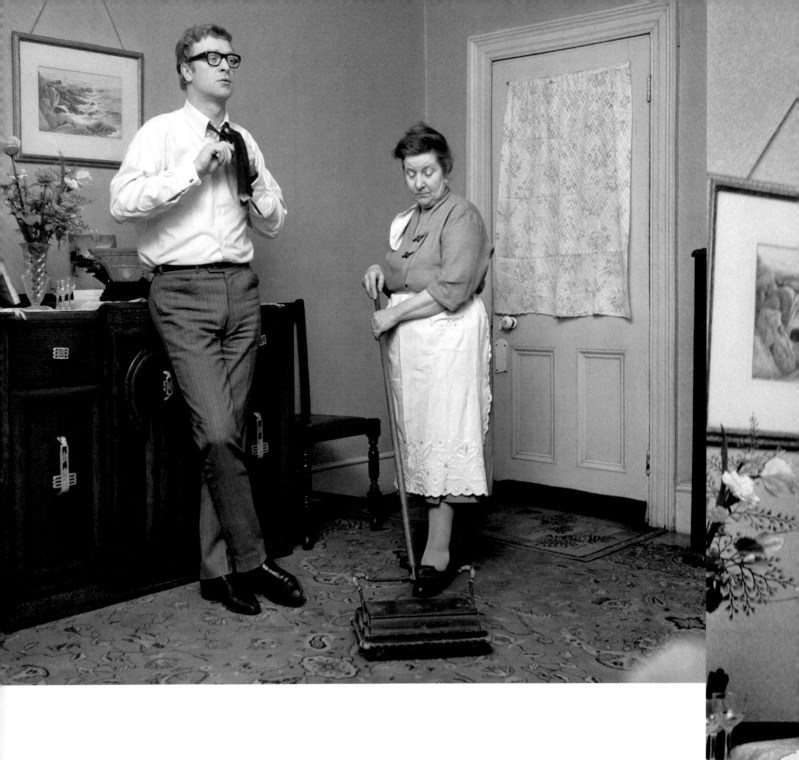

No place like home. The year was 1964 and Caine's mother,
Ellen, makes sure her boy and her house are spick and span before
the photographs are taken.

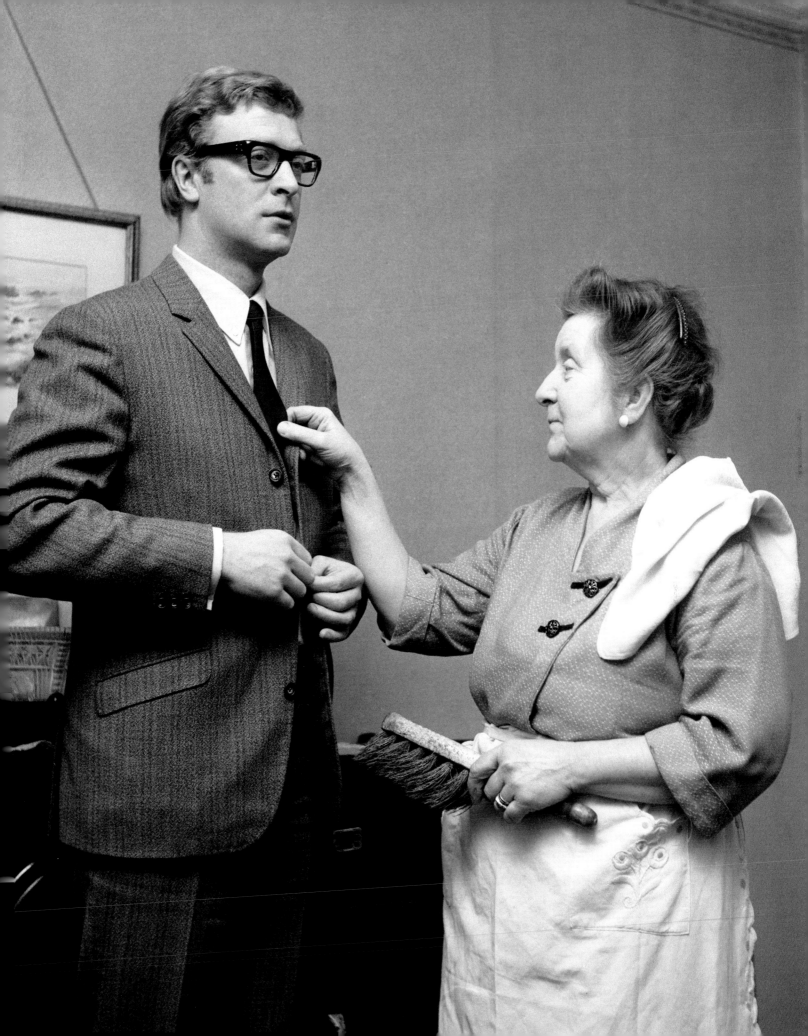

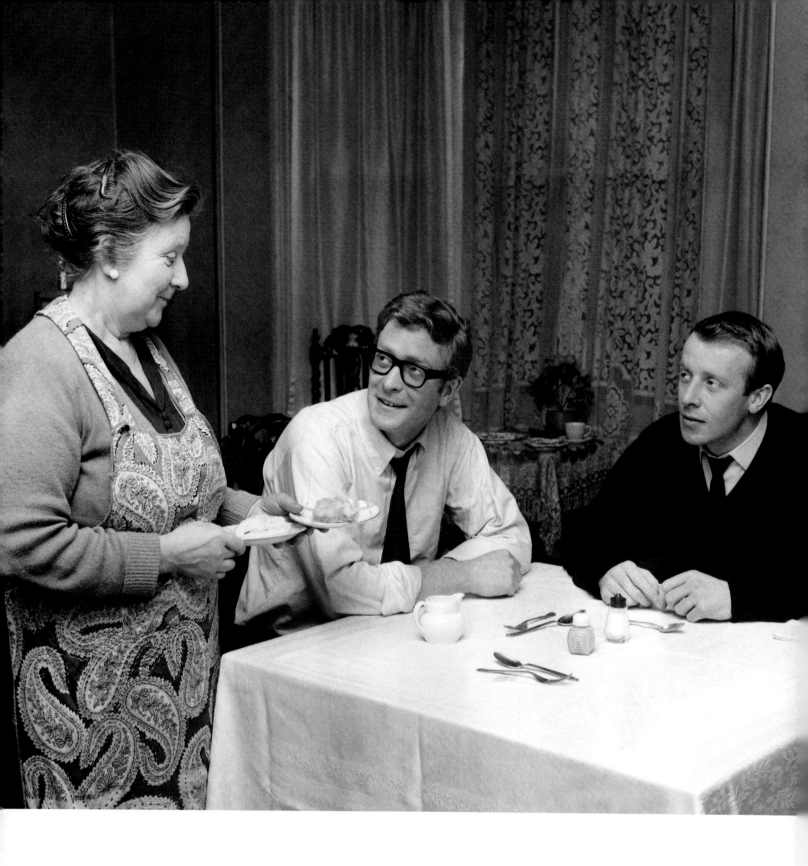

The Elephant and Castle, 1964. Caine's mother makes tea for her two sons,
Michael and Stanley. And then it is off for a stroll to the shops.

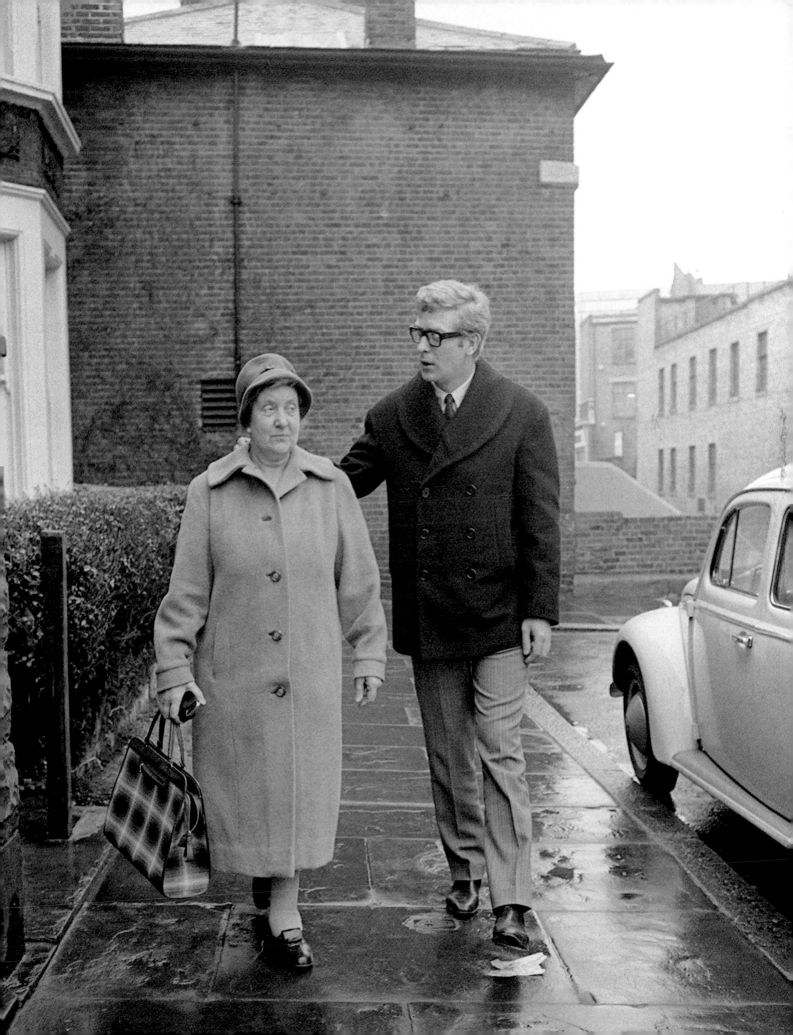

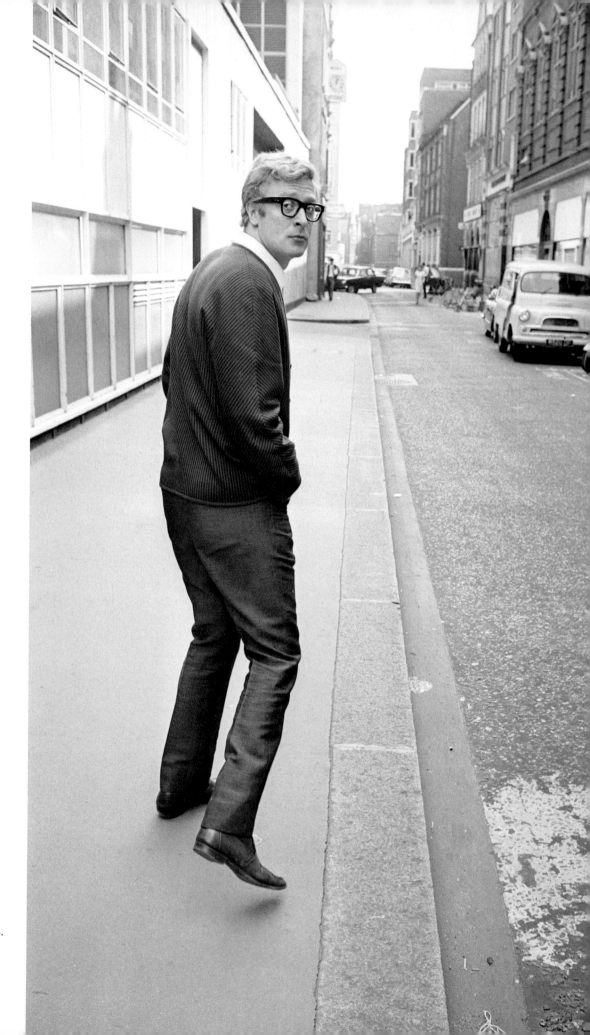

Street-wise. Michael Caine
walking the city streets he knows
so well in sharp 1960s off-duty
clothes. White button-down shirt,
short Italian-style knit cardigan,
narrow trousers and polished loafers.

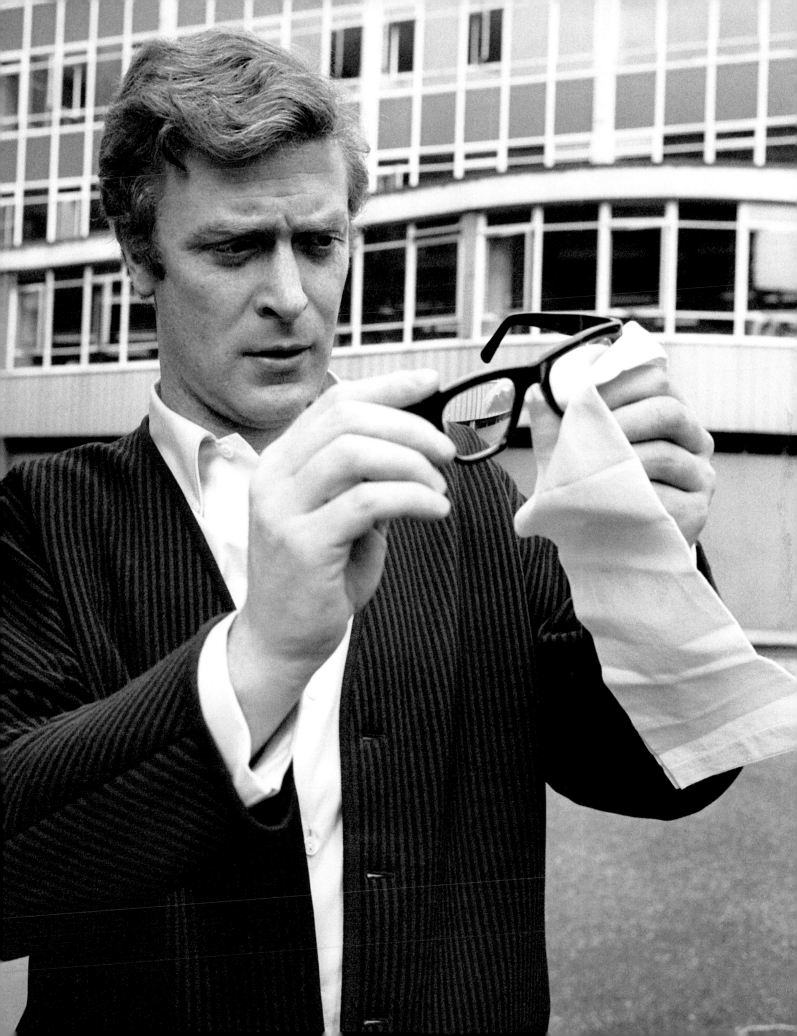

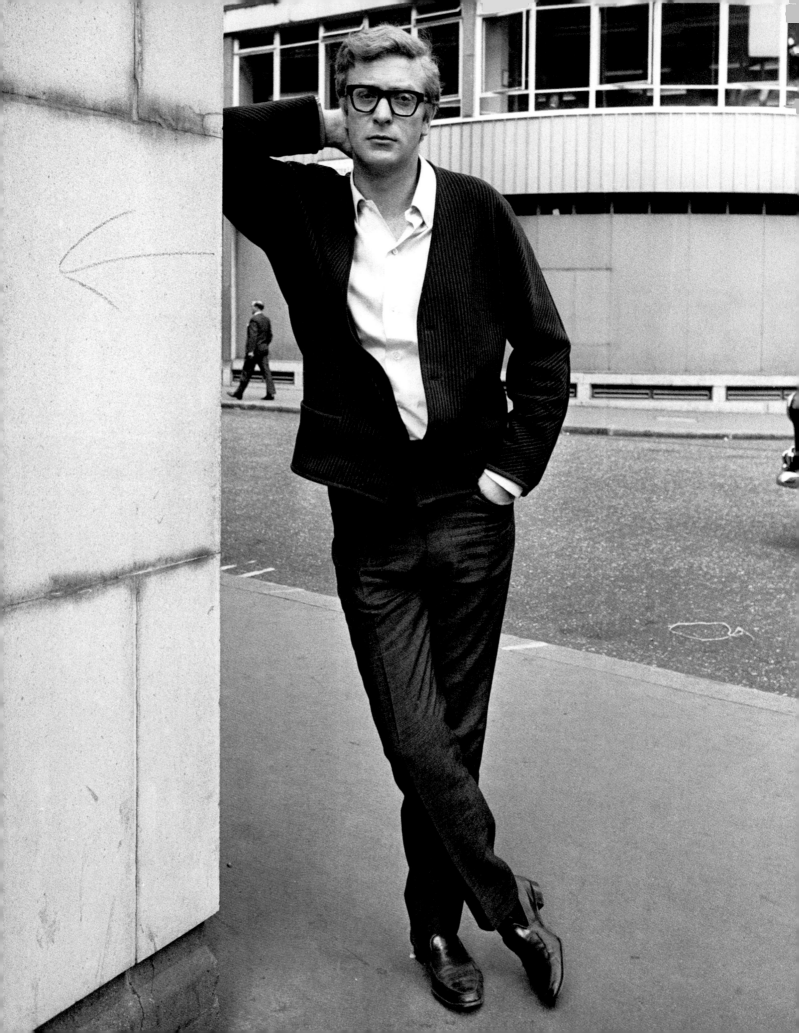

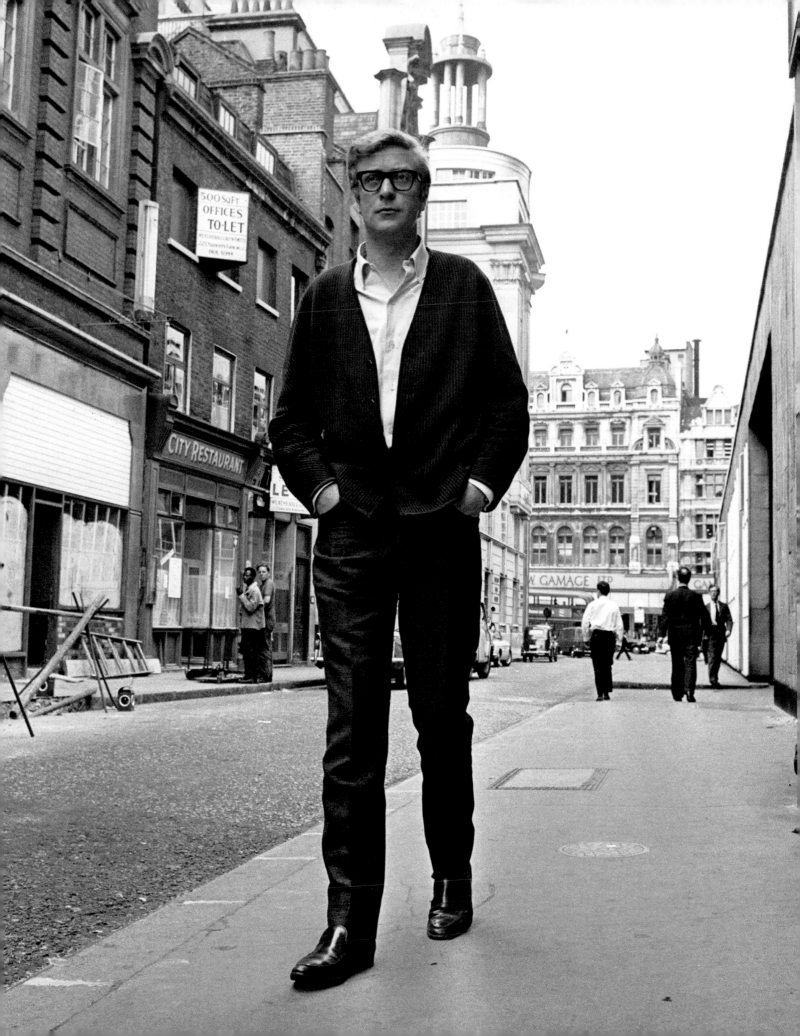

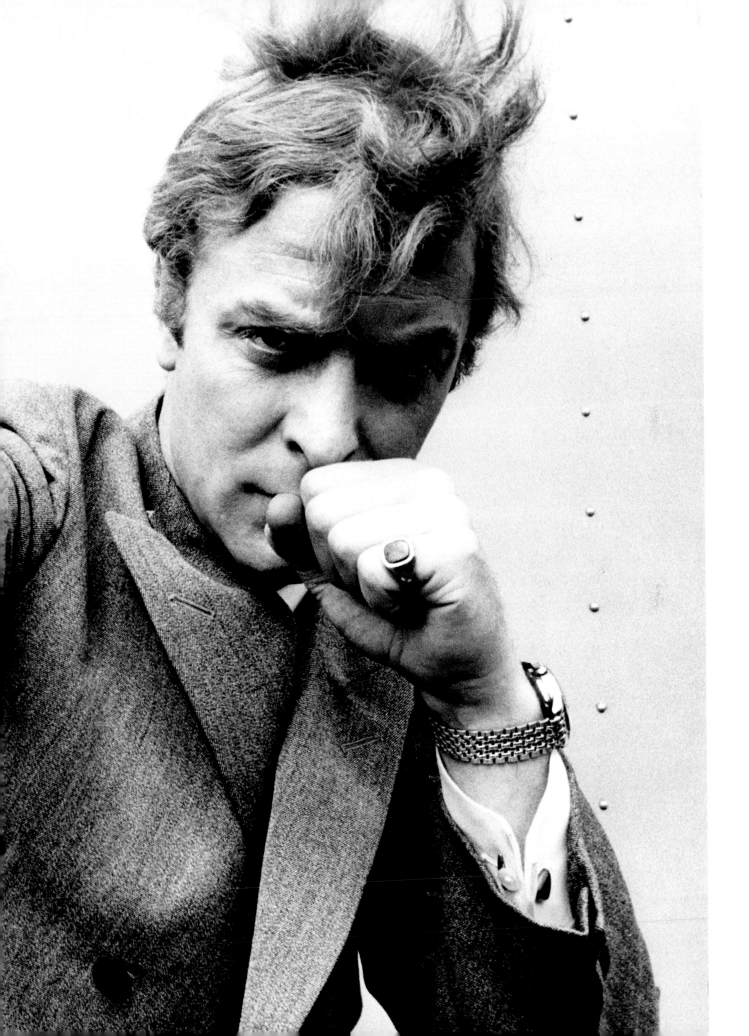

zulu 1964

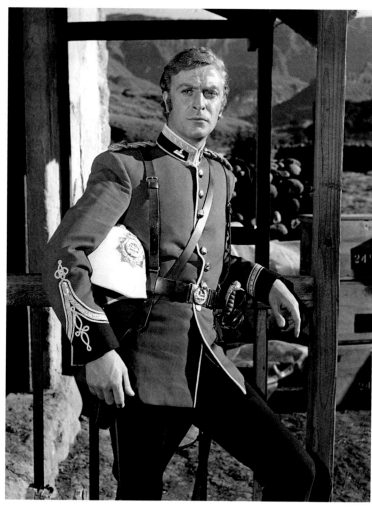

Caine looking very dapper as Lieutenant Gonville Bromhead
of the British Army's 24th Regiment of Foot in the 1964 movie,
ZULU. Apart from being one of the best war films of the
1960s, it also kick-started Caine's movie career.

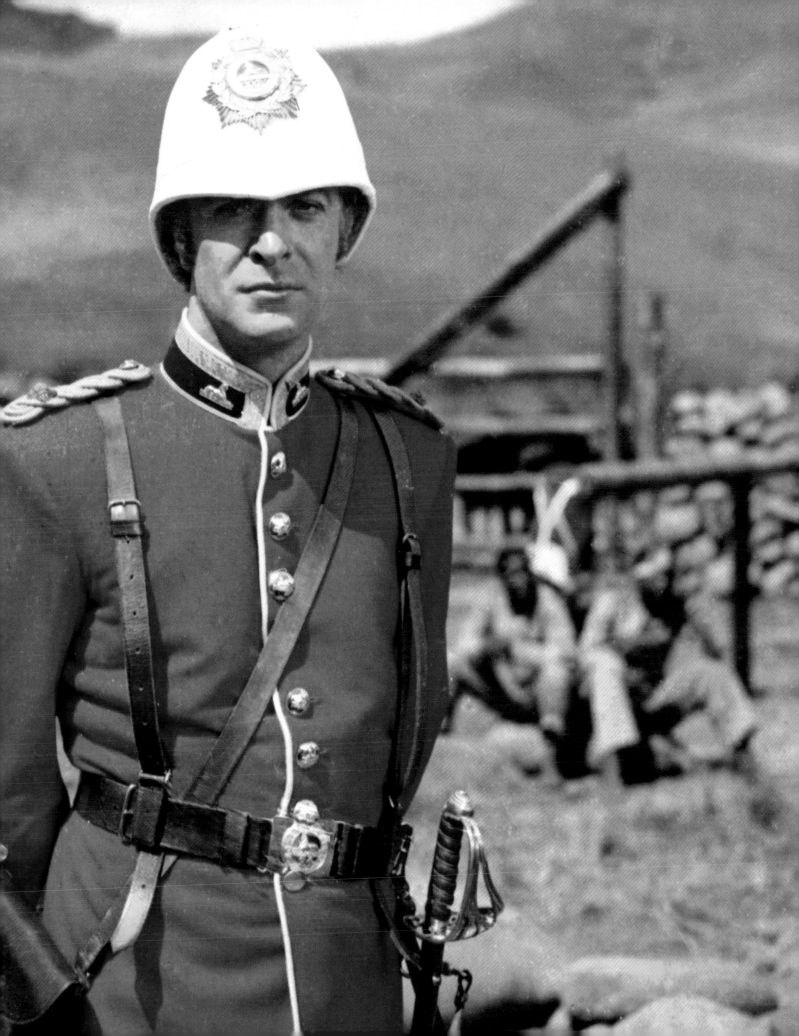

alfie 1966

'it seems to me if they ain't
got you one way they've got you another.
so what's the answer? that's what
i keep asking myself – what's it all
about? know what i mean?'

alfie elkins

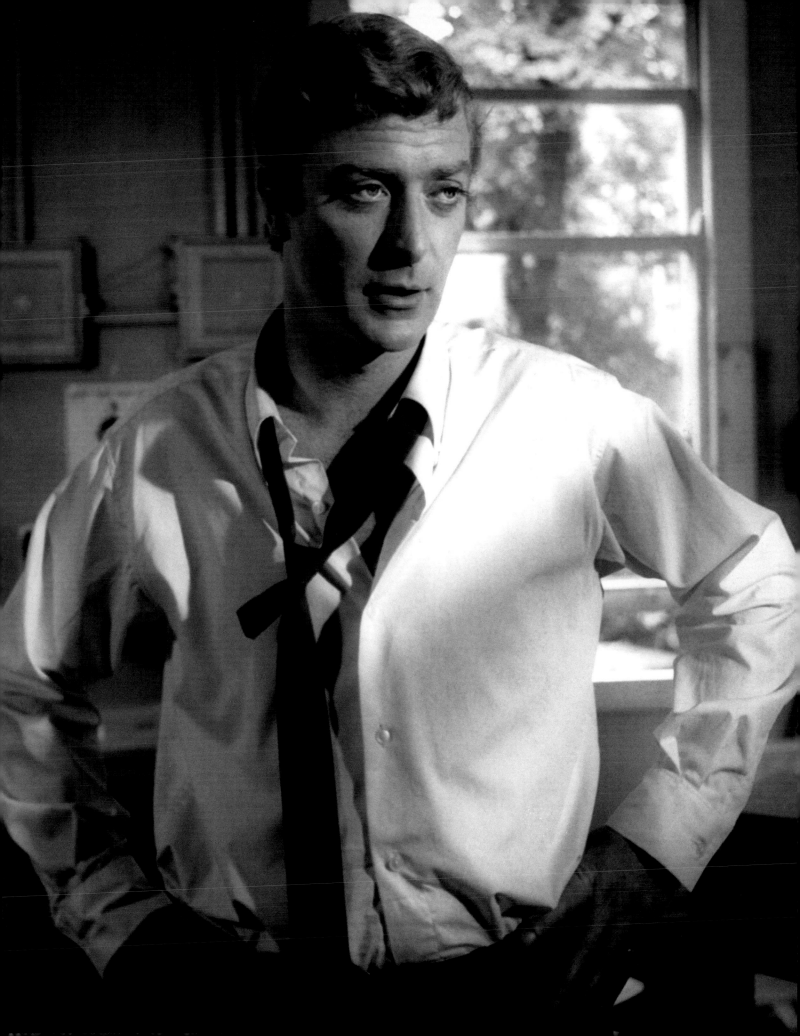

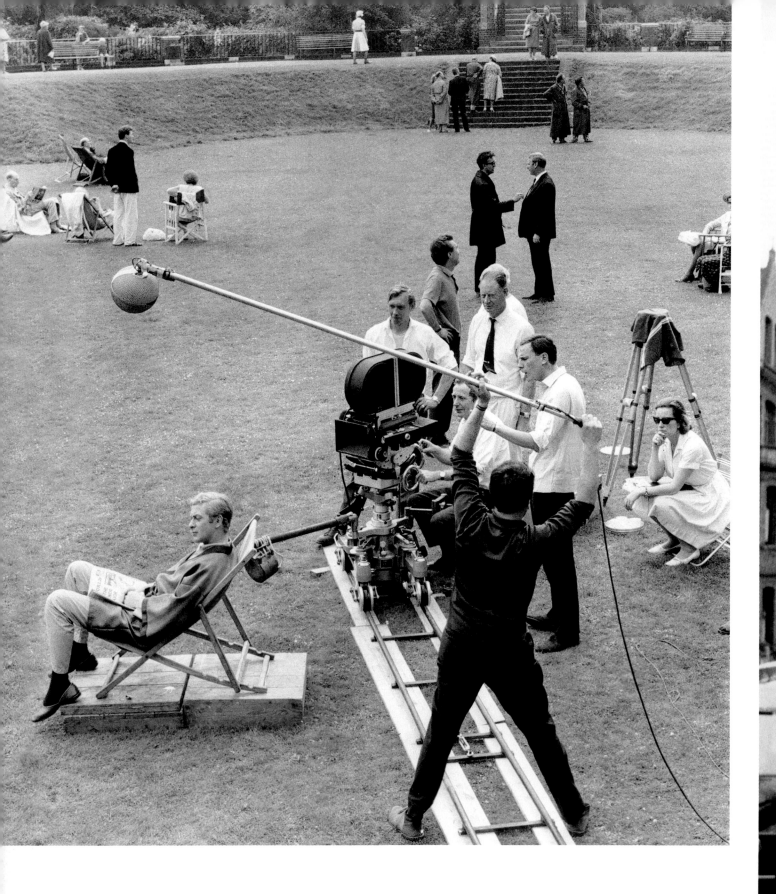

Above: Behind-the-scenes photograph of Caine and crew during the filming of the movie **ALFIE**. *Opposite*: The incorrigible womaniser, Alfie, cannot resist a quick cuddle with Carla, the off-duty convalescent home nurse.

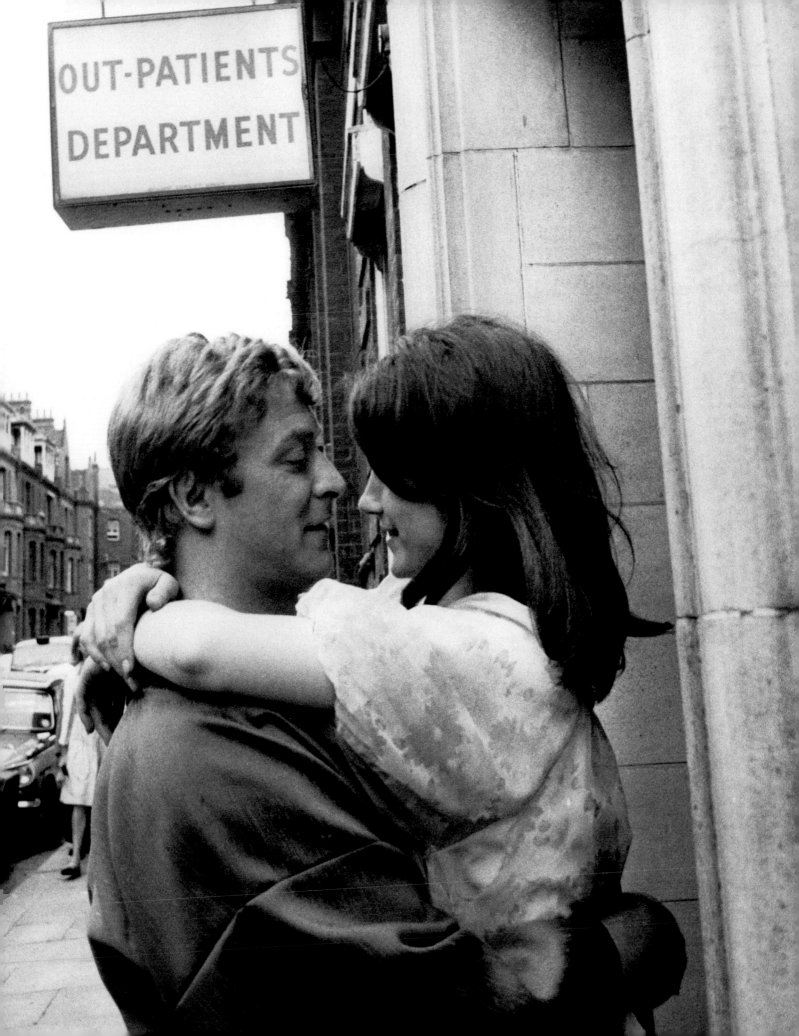

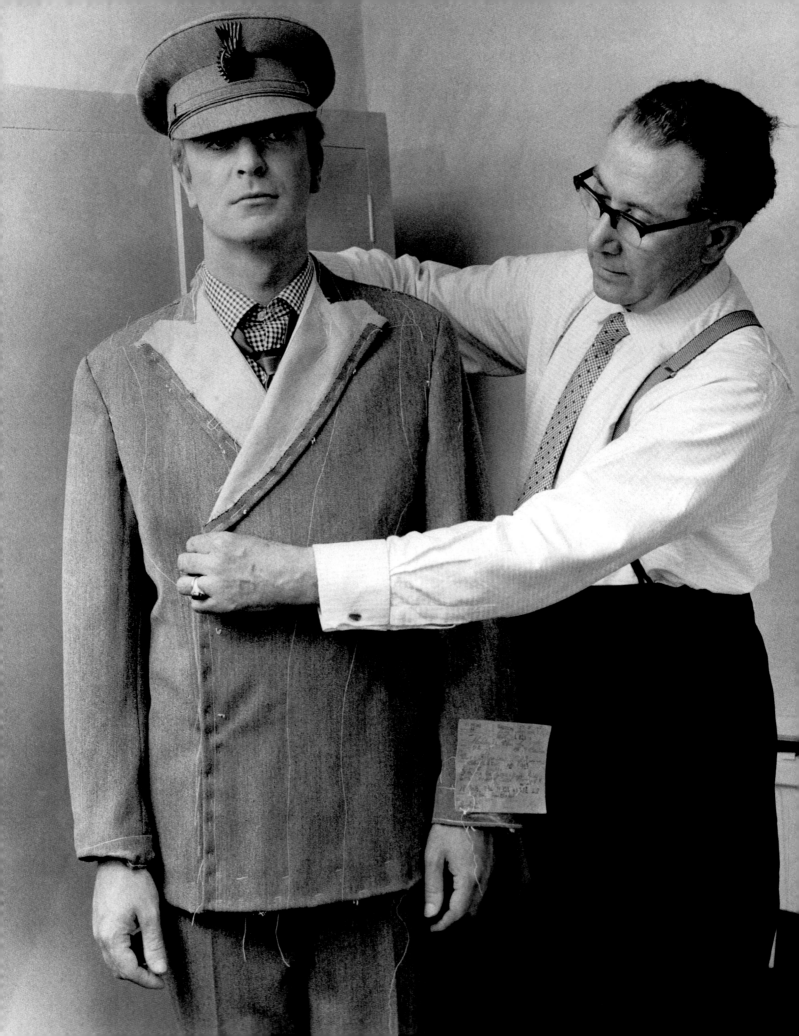

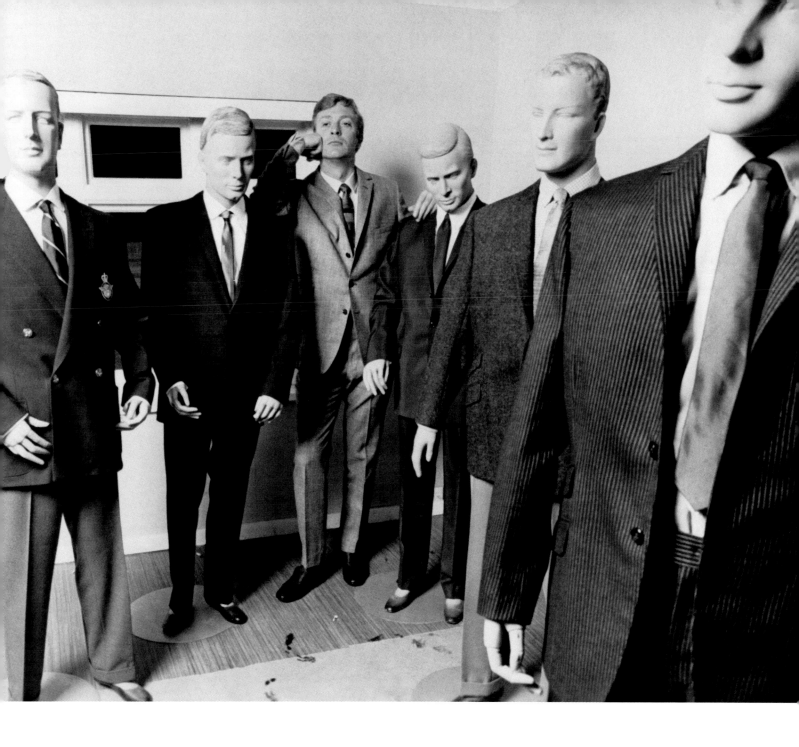

Above: Michael Caine poses arrogantly in the centre of a group of tailor's dummies in a sharp, handmade Doug Hayward suit. *Opposite*: Suits you sir! Alfie being fitted for his chauffeur's uniform.

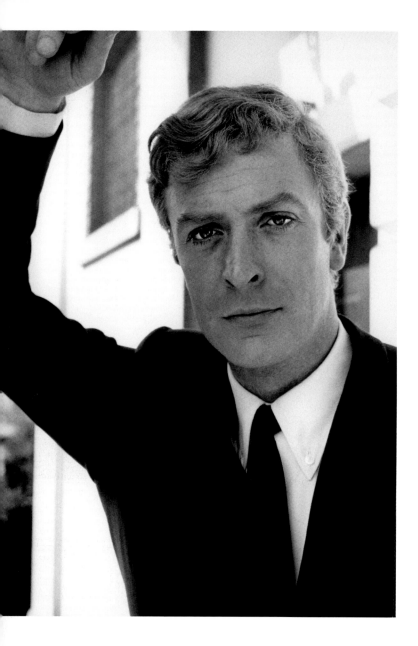

Above: An off set portrait of Caine as Alfie Elkins.
Opposite: Michael Caine and the director of **ALFIE**, Lewis Gilbert, discuss the next scene in the movie.

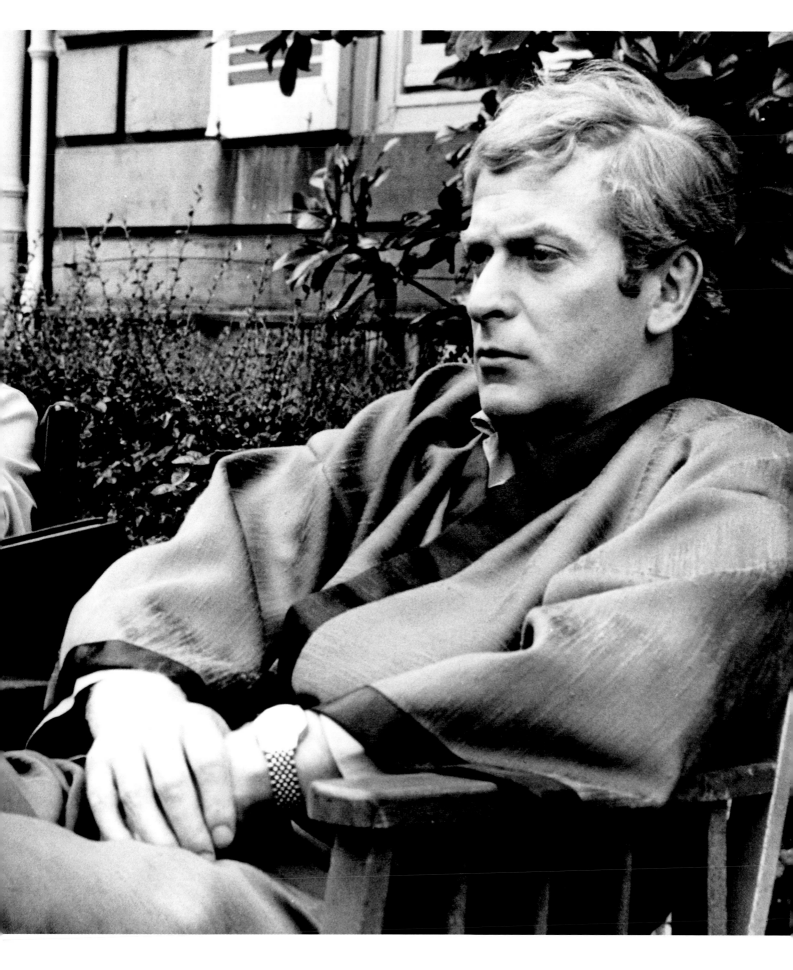

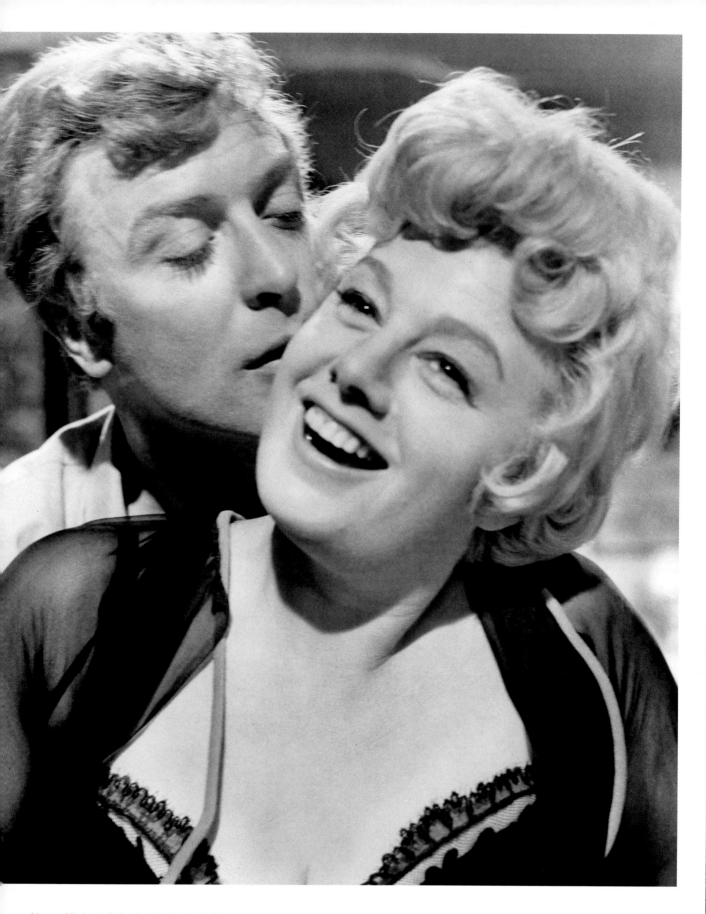

Above: Michael Caine having fun with Shelley Winters.
Opposite: Getting serious with Jane Asher.

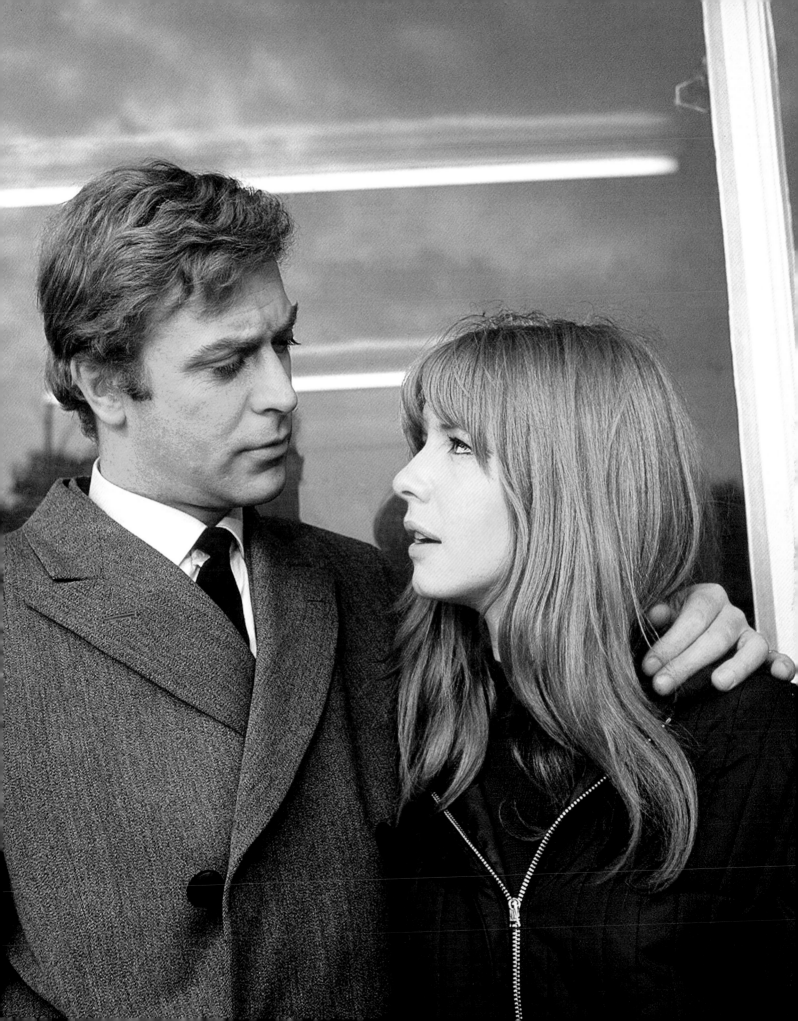

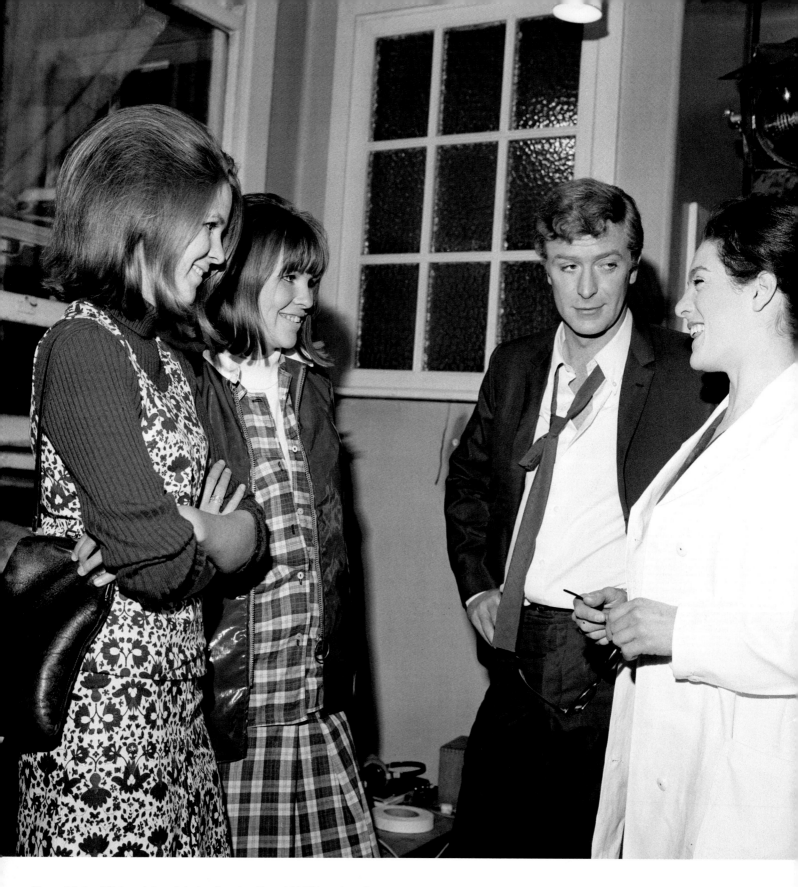

Above: Michael Caine pictured during the shooting of **ALFIE**, on location at the old Royal Victoria Hospital. Also pictured with Caine are Eleanor Bron and the Jay twins, Catherine and Helen. *Opposite*: A close-up publicity portrait for **ALFIE** in which Caine is wearing a very fine gingham shirt.

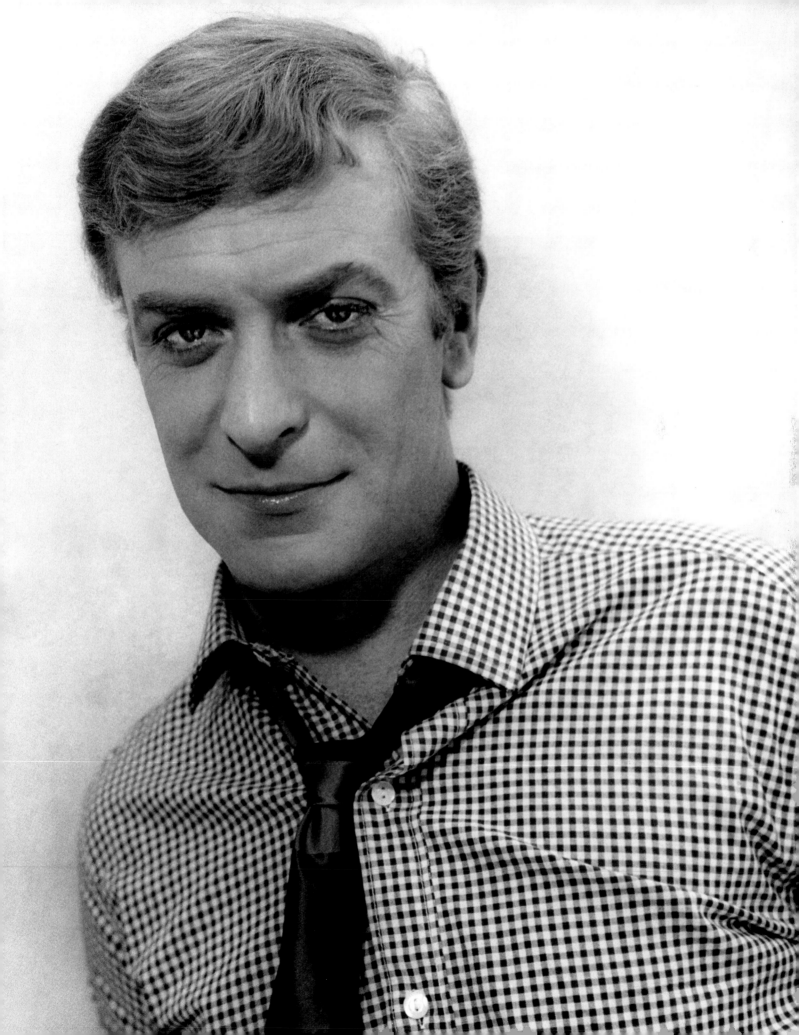

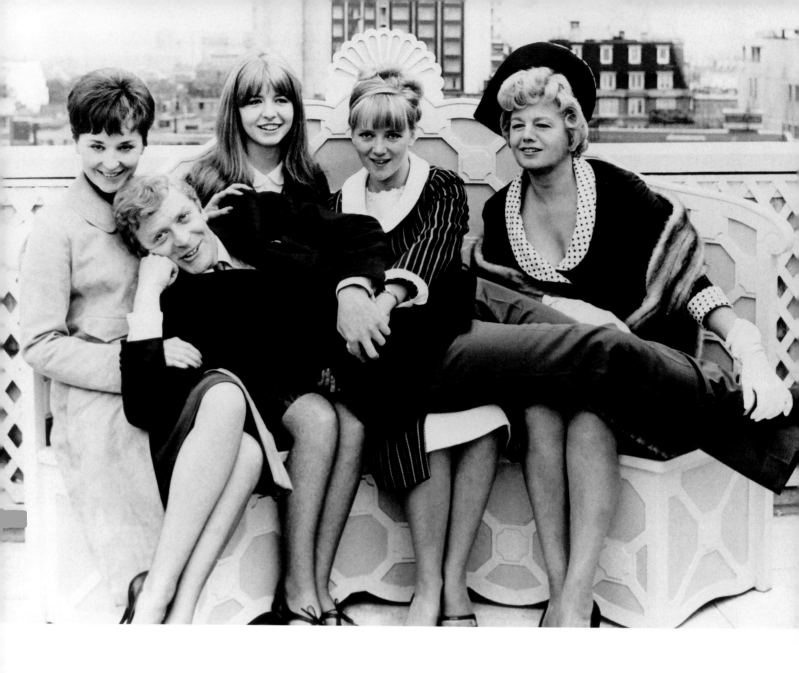

Above: Bring on the girls. Michael Caine in his element with **ALFIE** co-stars (from left to right) Vivien Merchant, Jane Asher, Julia Foster and Shelley Winters. *Opposite*: During the 1966 Cannes Film Festival Caine is surrounded by shapely models with the film's title, **ALFIE**, stamped on their skin-tight trousers. The things an actor does for publicity.

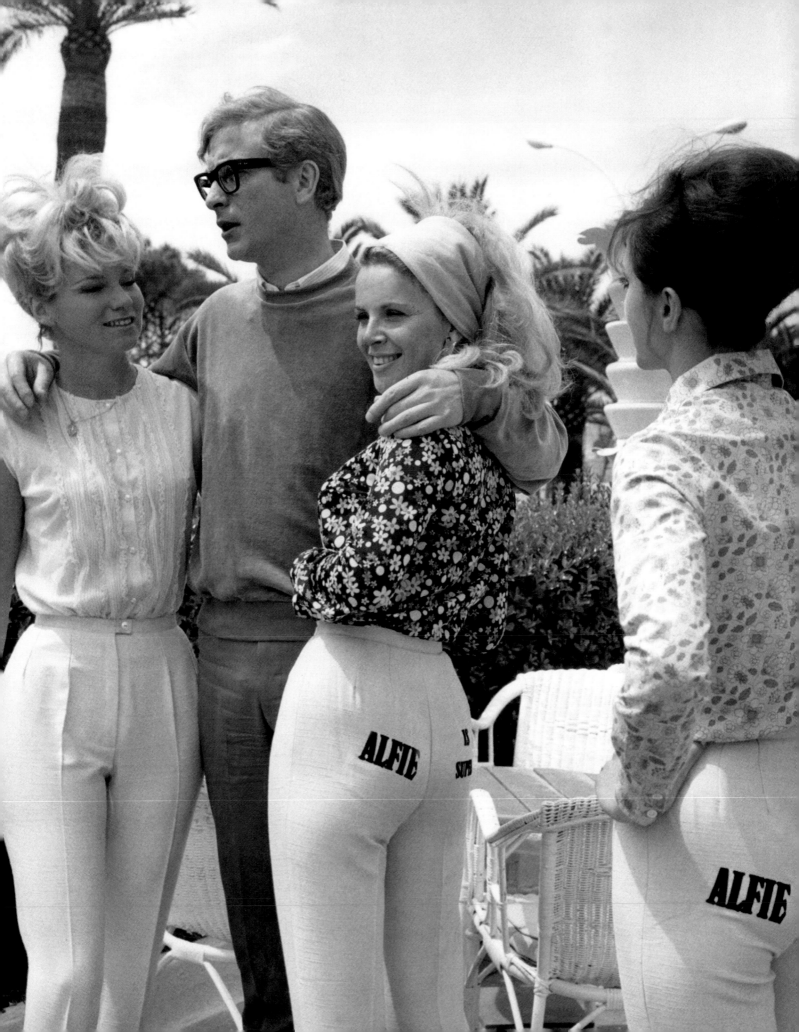

the ipcress file
1965

'my name is harry palmer...'

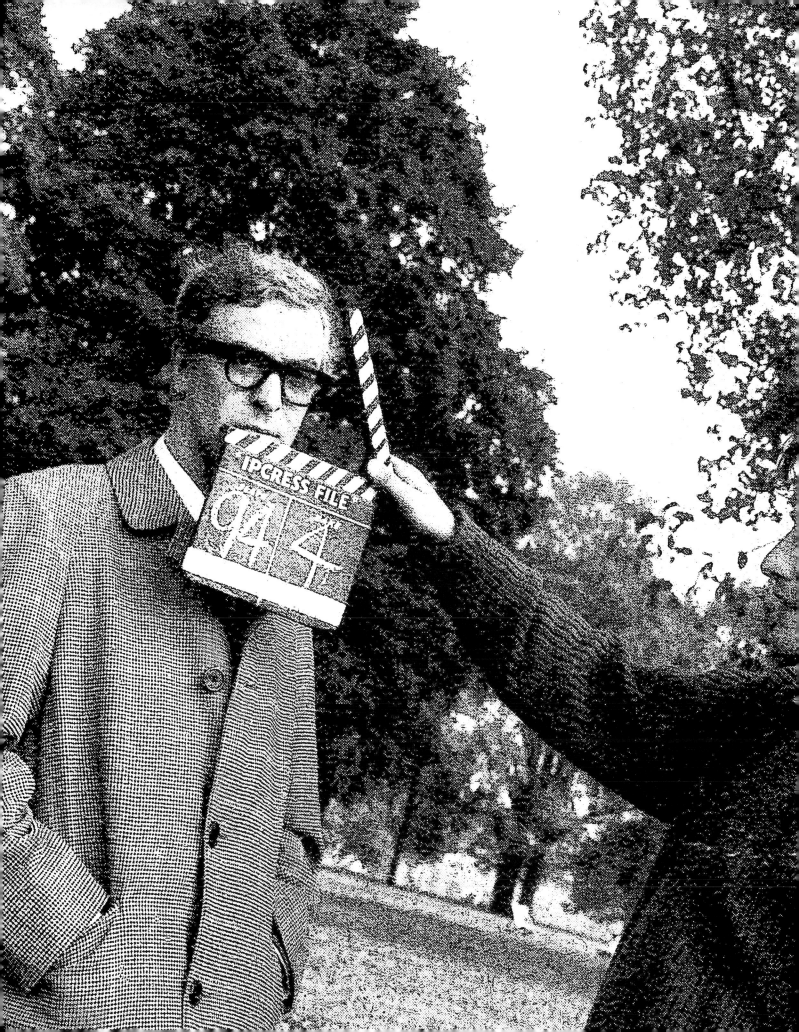

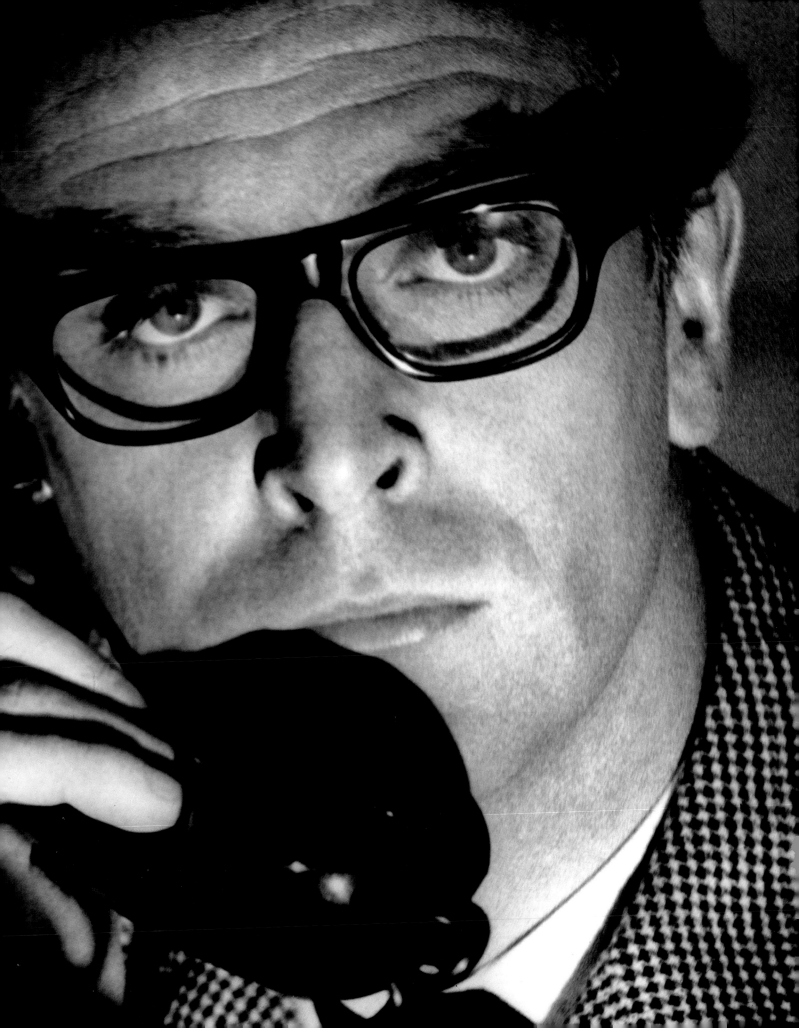

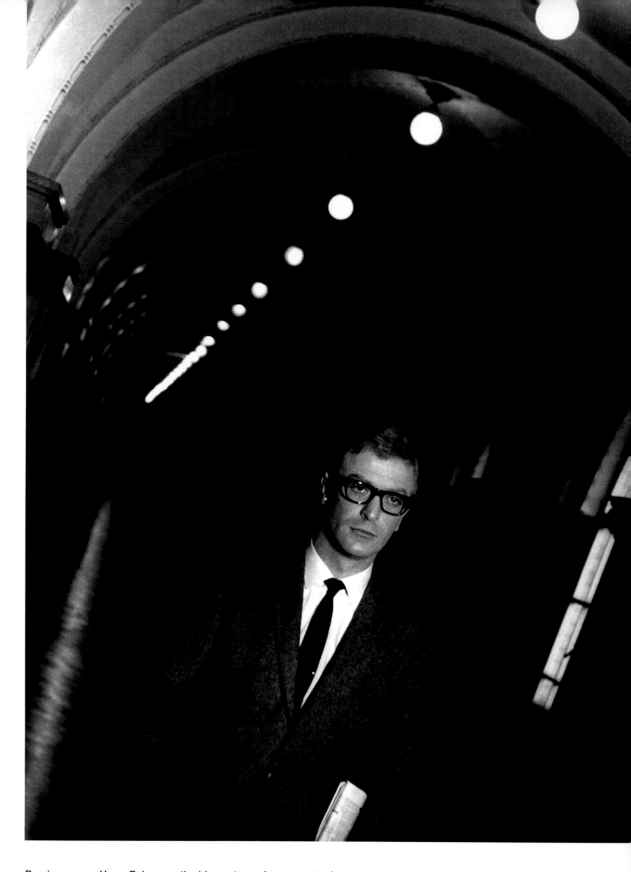

Previous page: Harry Palmer on the blower to espionage central.
Above: By wearing his special **IPCRESS FILE** glasses, Michael Caine is transformed into the laconic anti-hero spy, Harry Palmer. It was the first time an action hero wore glasses in a movie. *Opposite*: A great close-up shot of Caine and **IPCRESS FILE** co-star, Nigel Green.

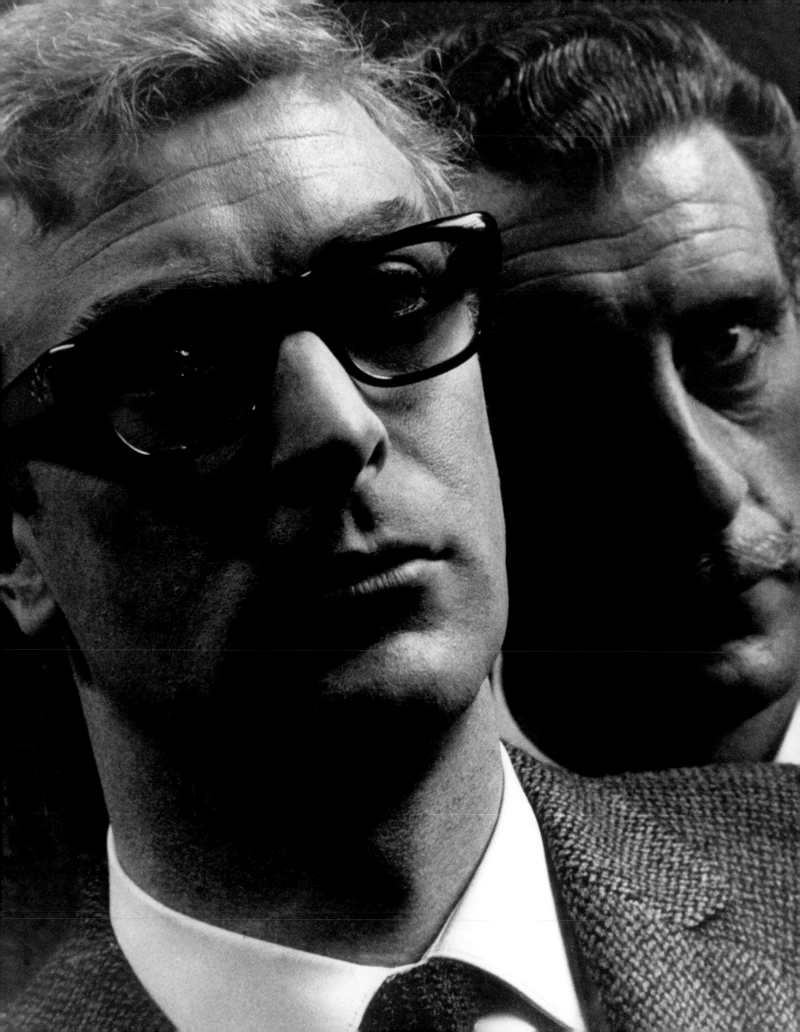

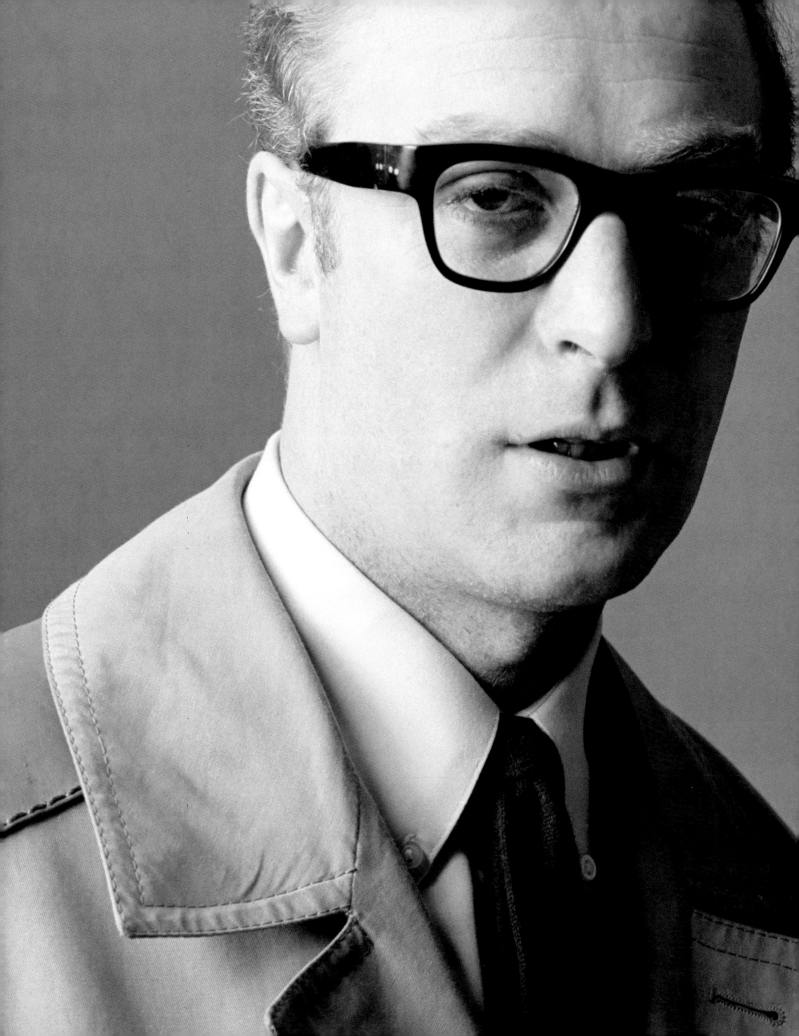

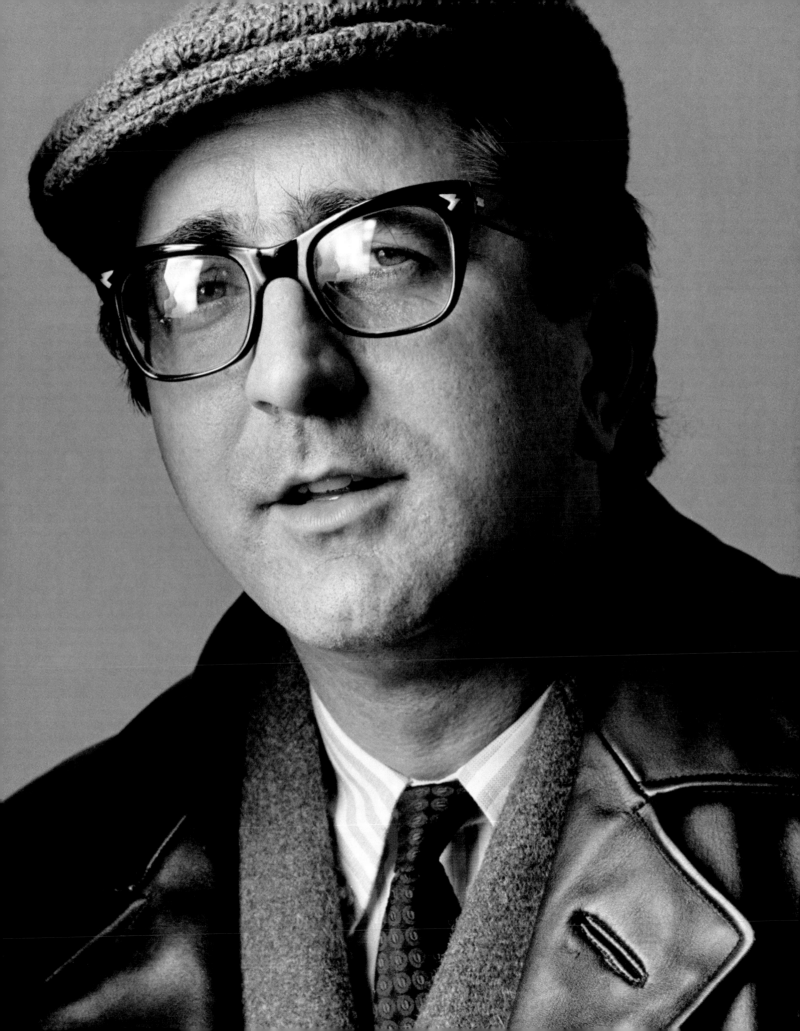

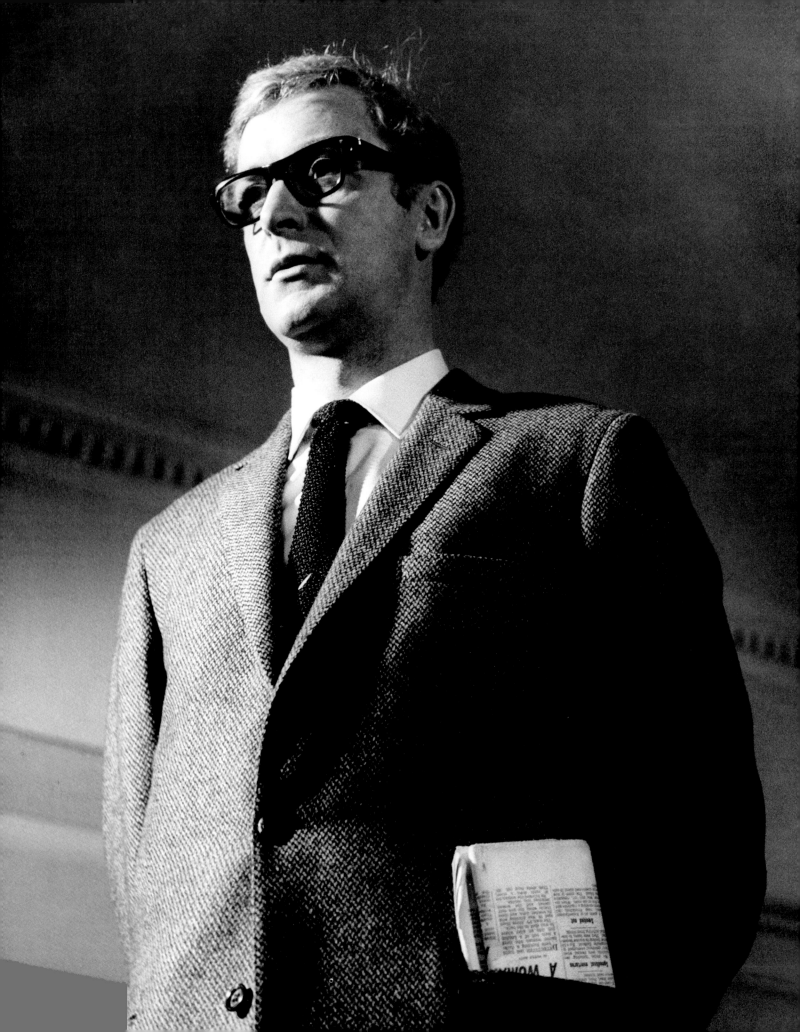

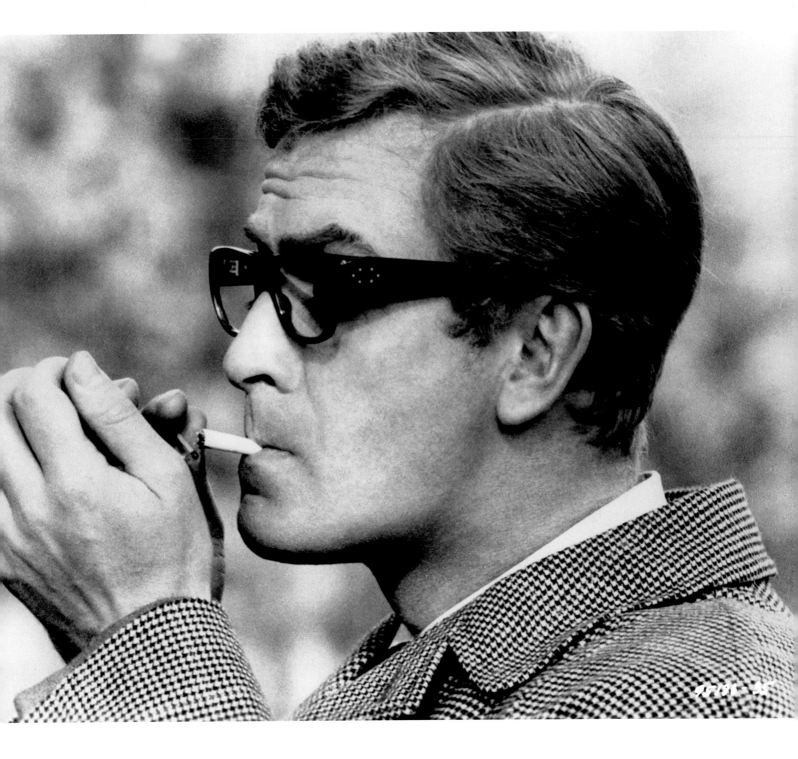

Previous page: The likely lads. Michael Caine with Len Deighton in 1965.
Caine had secured the plum role of Harry Palmer in **THE IPCRESS FILE**,
a film based on Deighton's 1962 novel of the same name.
Above: Caine lights up between scenes. *Opposite*: **THE IPCRESS FILE**
was an ironically downbeat alternative portrait of the world of spies, at a
time when the successful James Bond movies dominated the big screen.

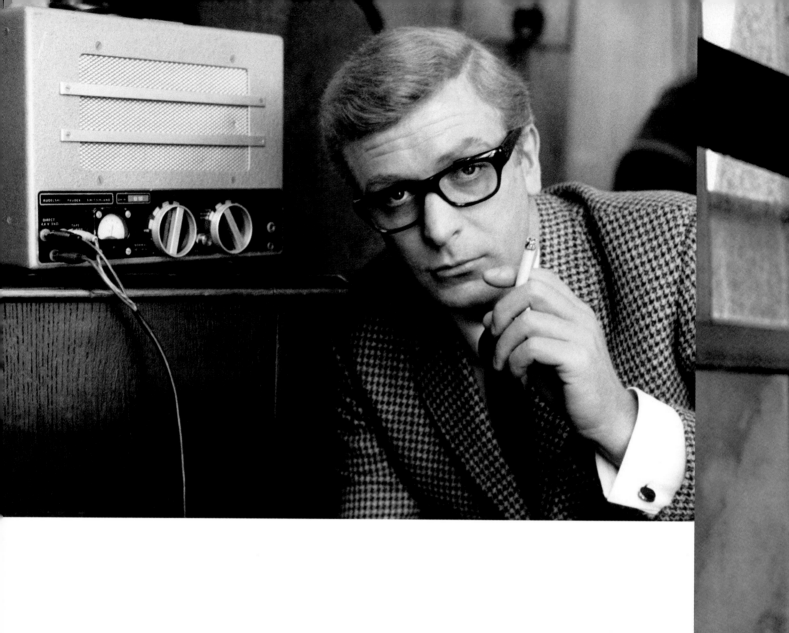

'My name is Harry Palmer ... and I'm a nosey neighbour.'
Michael Caine in the classic stake-out scene in **THE IPCRESS FILE**.

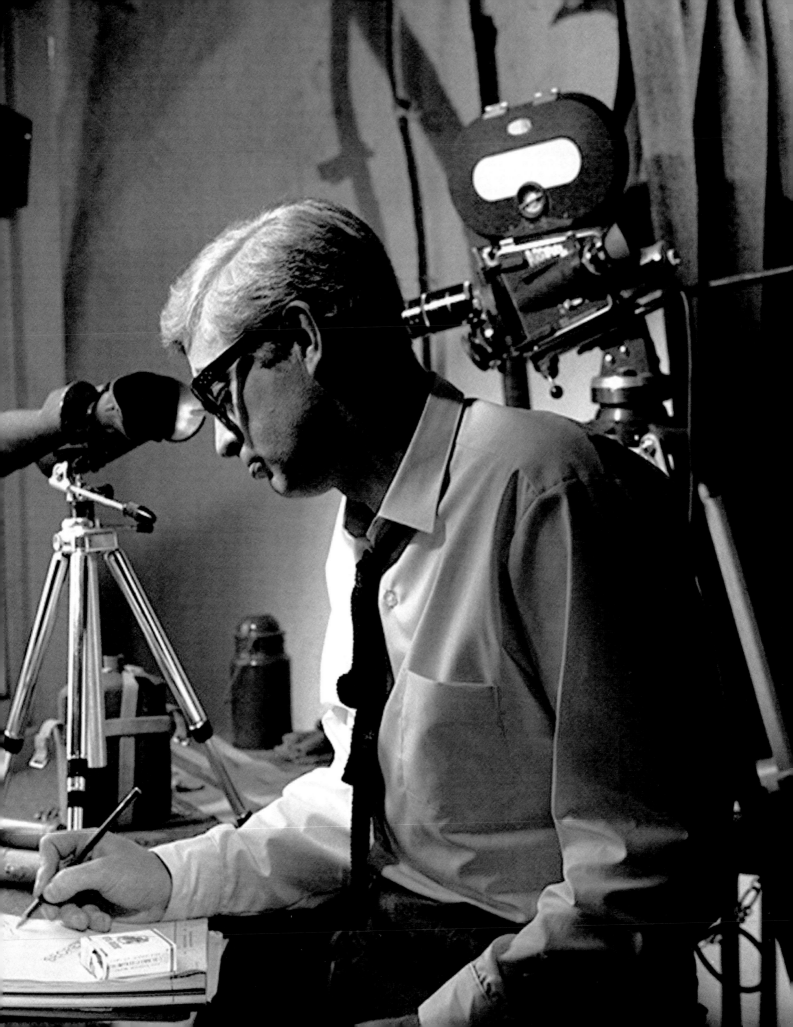

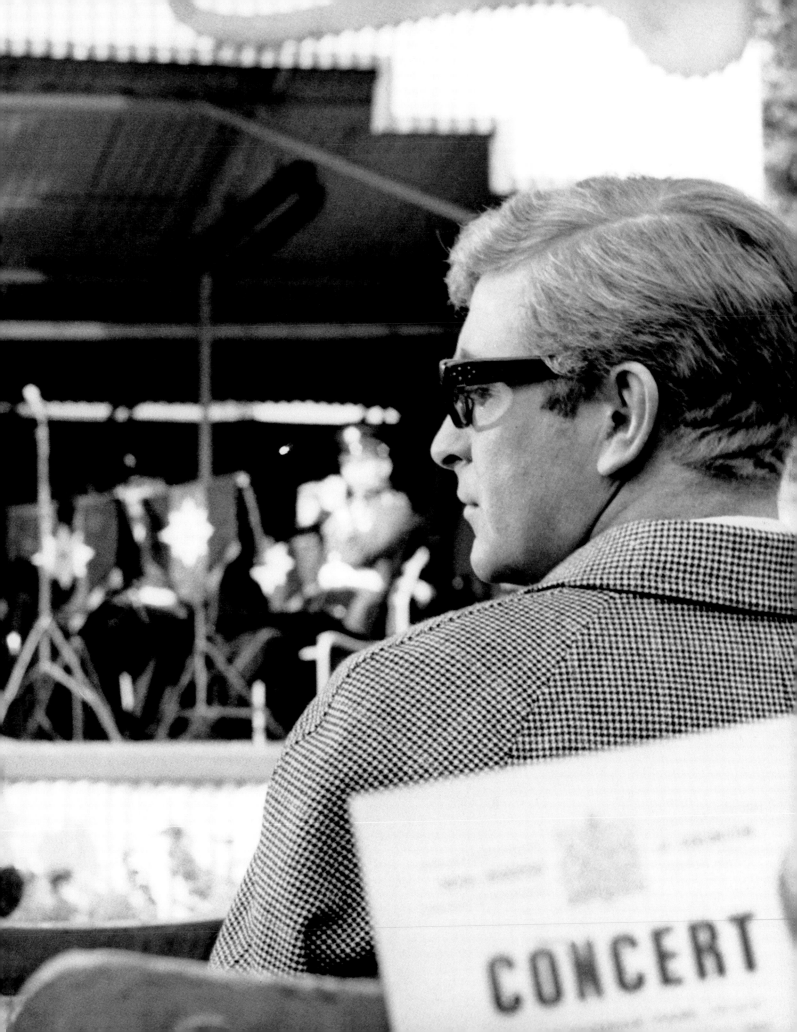

CONCERT

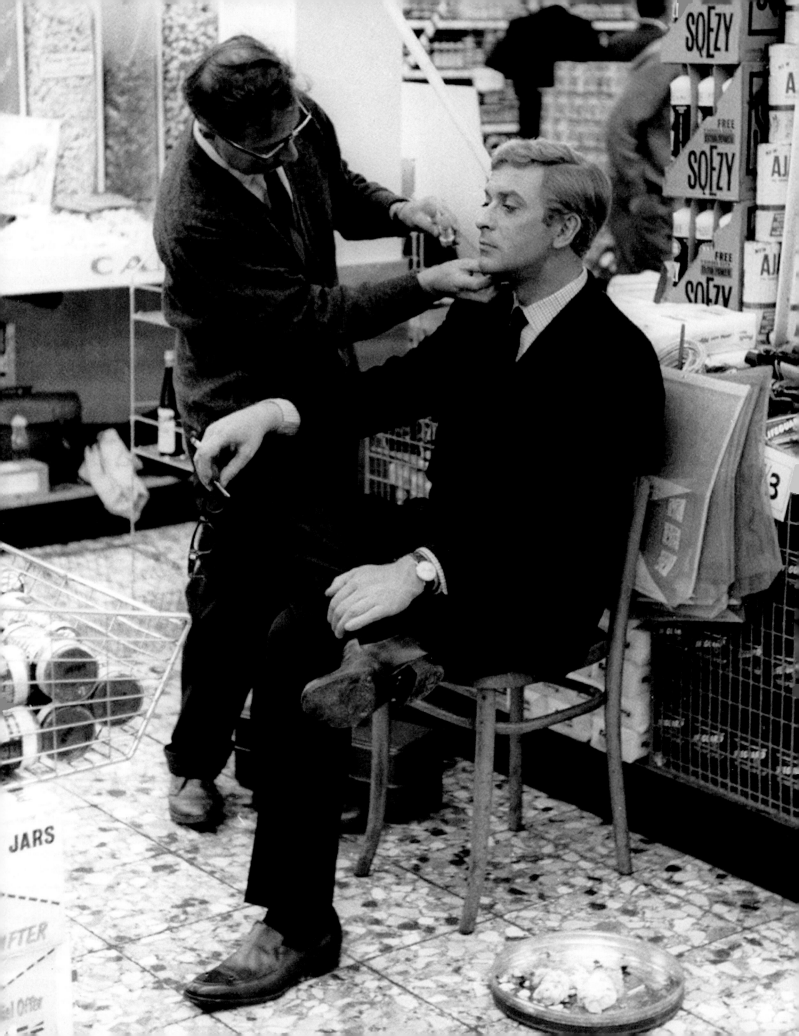

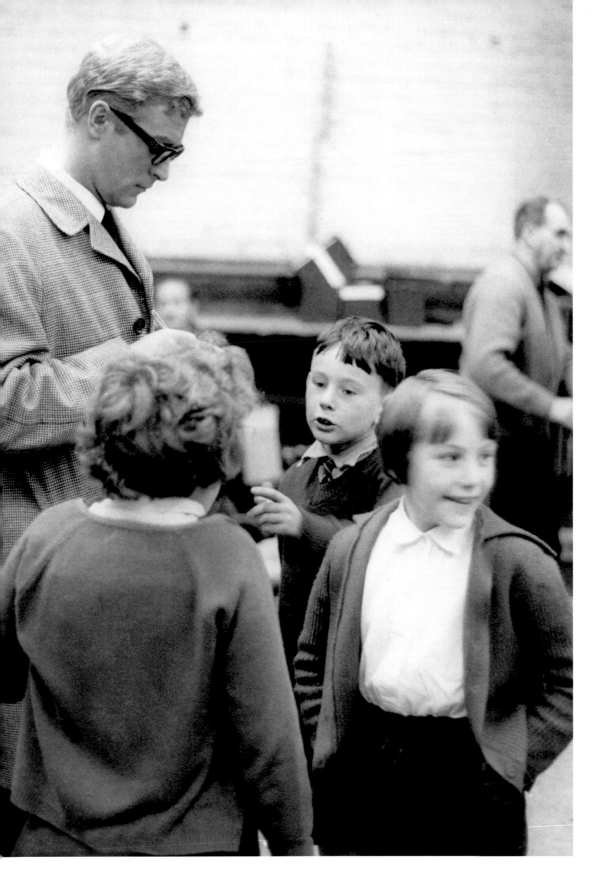

Previous page: Harry Palmer meets his controller by the bandstand in the park. *Above*: Michael Caine signing autographs for young fans. *Opposite*: Caine having his make-up refreshed before a take in the supermarket scene in **THE IPCRESS FILE**.

61

funeral in berlin
1966

'it was going to be a lovely funeral. harry palmer just hoped it wouldn't be his…'

movie poster tag line

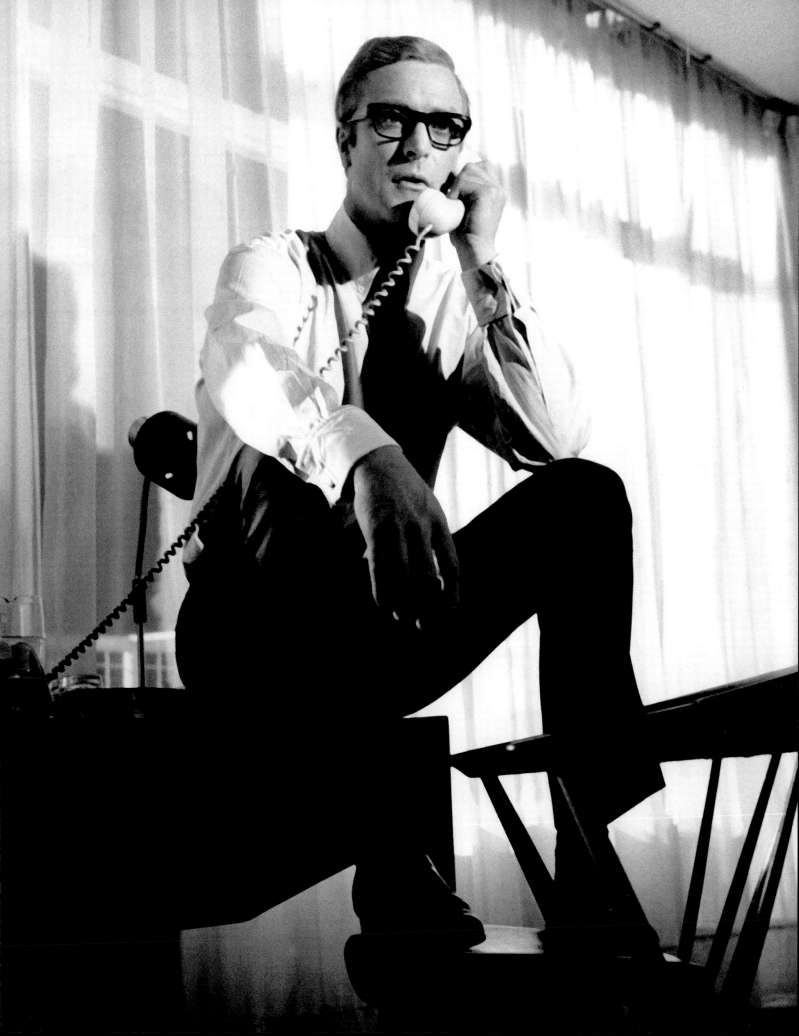

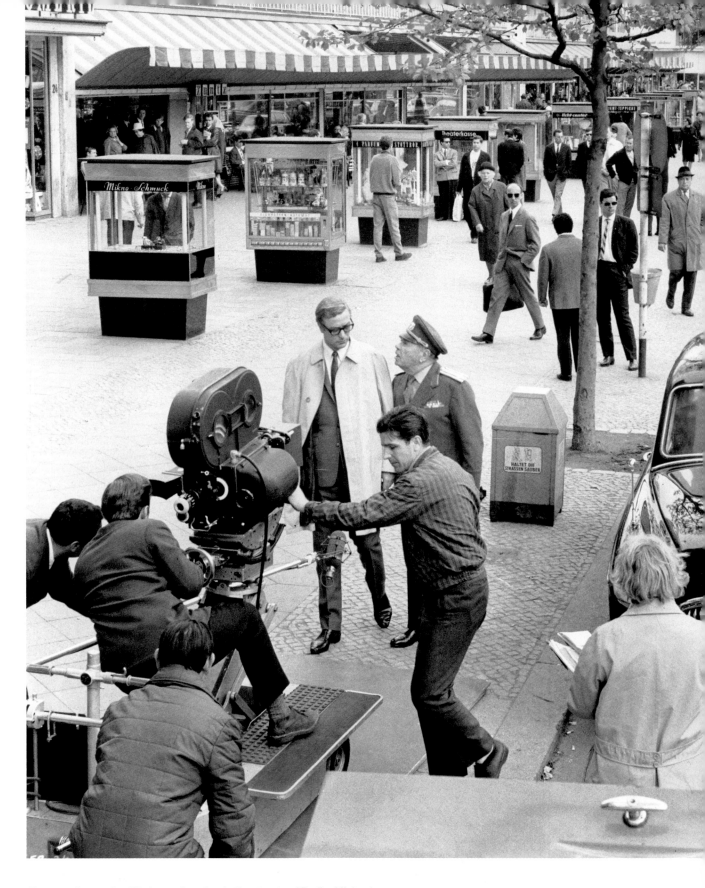

Above and *opposite*: Filming on location in the streets of Berlin, Michael Caine with Oskar Homolka. *Overleaf*: (Left to right) Executive Producer Charles Kasher, Eva Renzi (Samantha Steel), Len Deighton (author), Michael Caine and Paul Hubschmid (Johnny Vulkan).

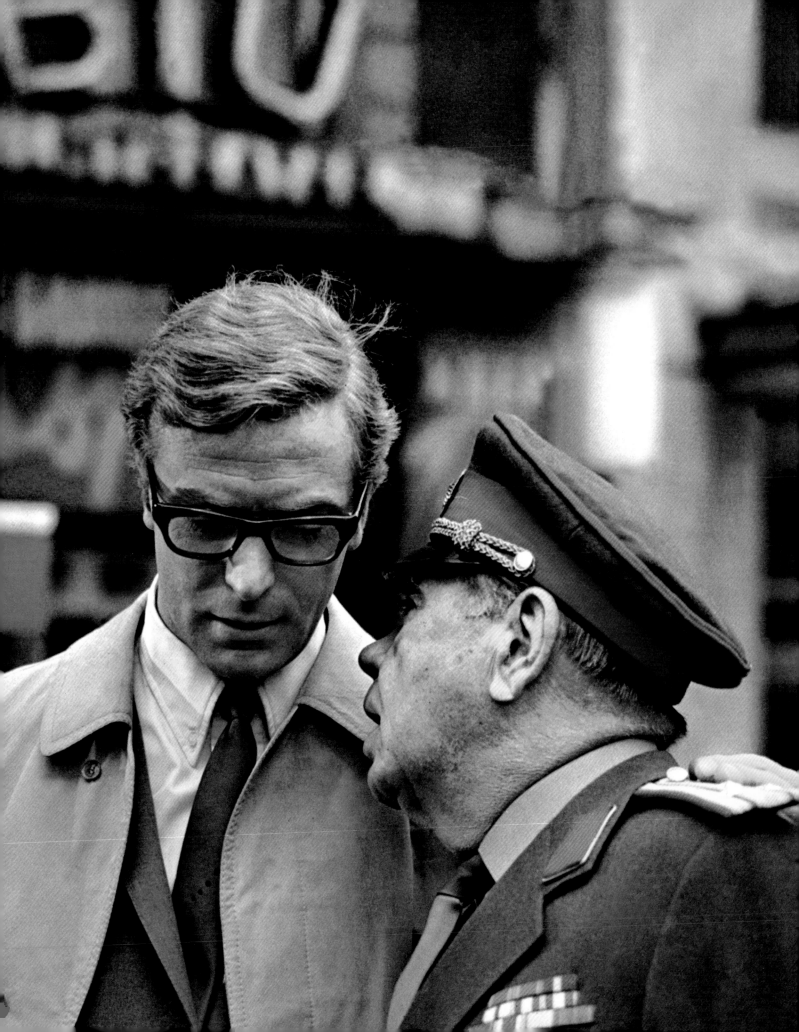

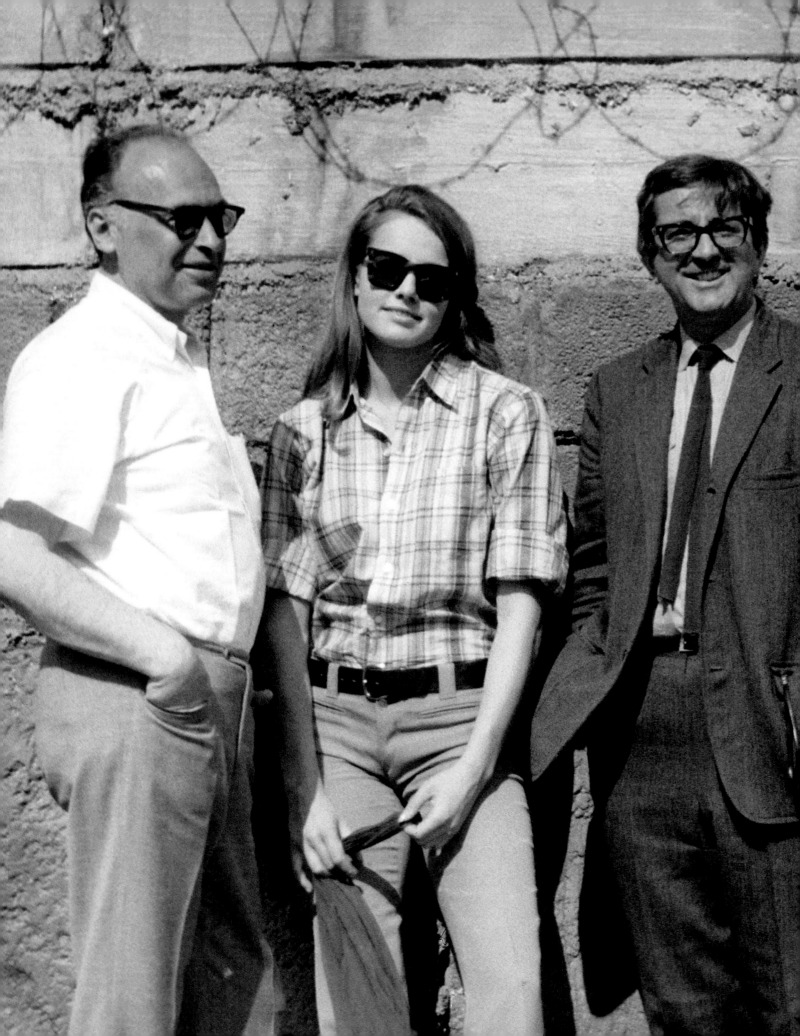

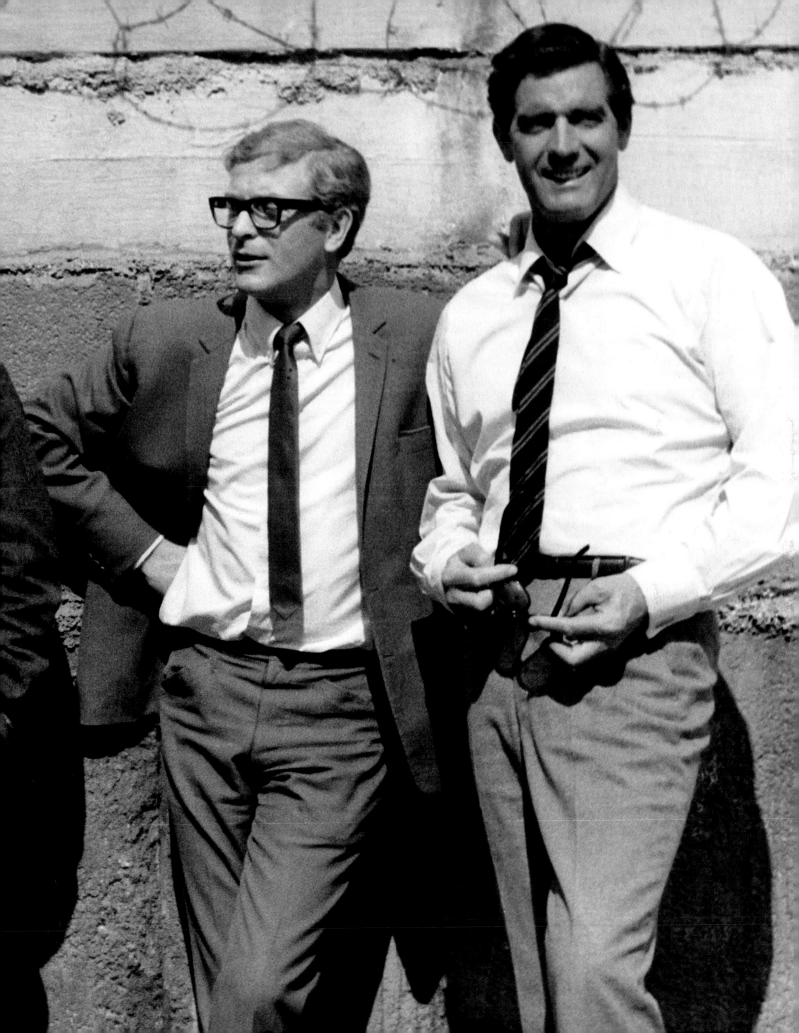

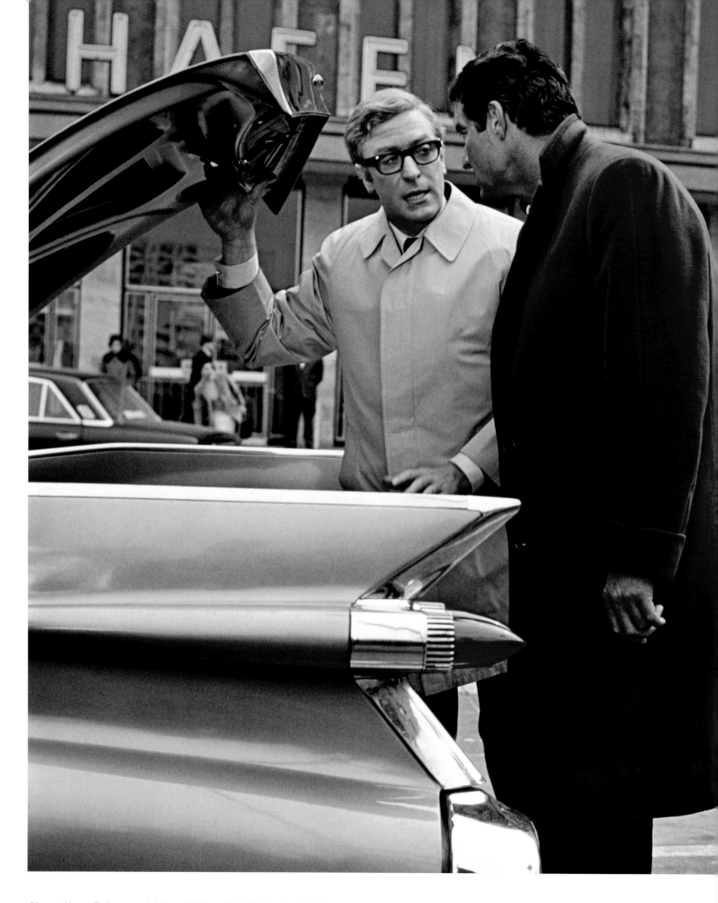

Above: Harry Palmer and Johnny Vulkan (Paul Hubschmid) discuss
the contents in the trunk of the flash American motor on a Berlin street.
Opposite: Caine takes aim as agent Harry Palmer in **FUNERAL IN BERLIN**.

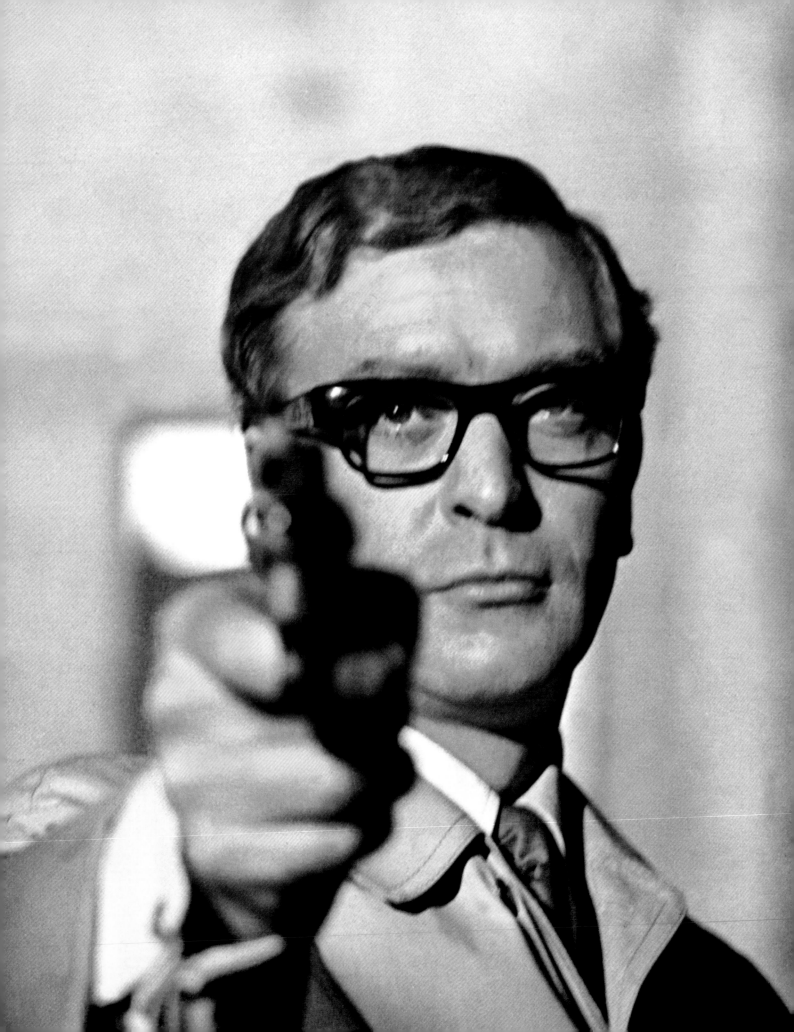

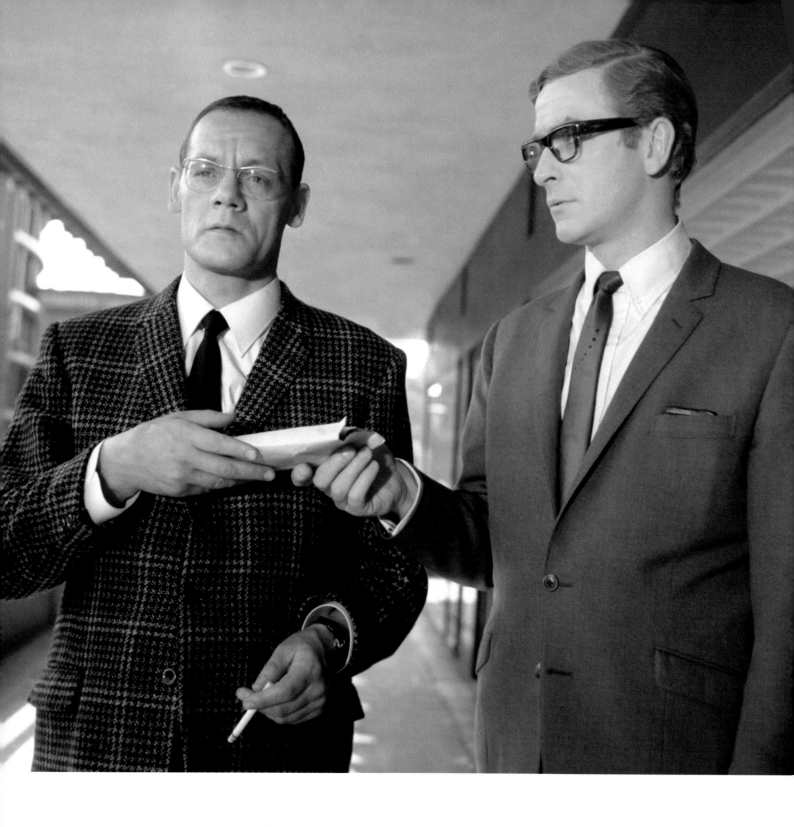

Above: Harry Palmer receives the documents from
Günter Meisner. *Opposite*: Michael Caine and Eva Renzi
pause outside a nightclub in the seedy part of Berlin.

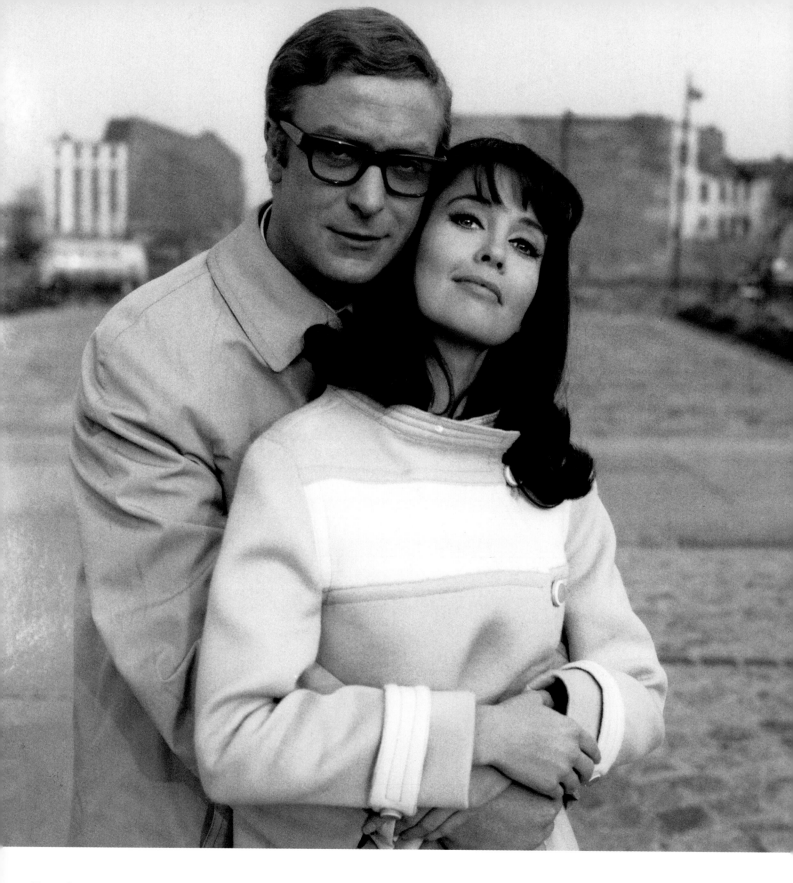

Above: Off set, Caine and Anjanette Comer smile for the camera. Comer was originally assigned to the film but was replaced by Eva Renzi due to illness. *Opposite*: Harry Palmer, waiting for his contact, stays warm in his trusty British raincoat.

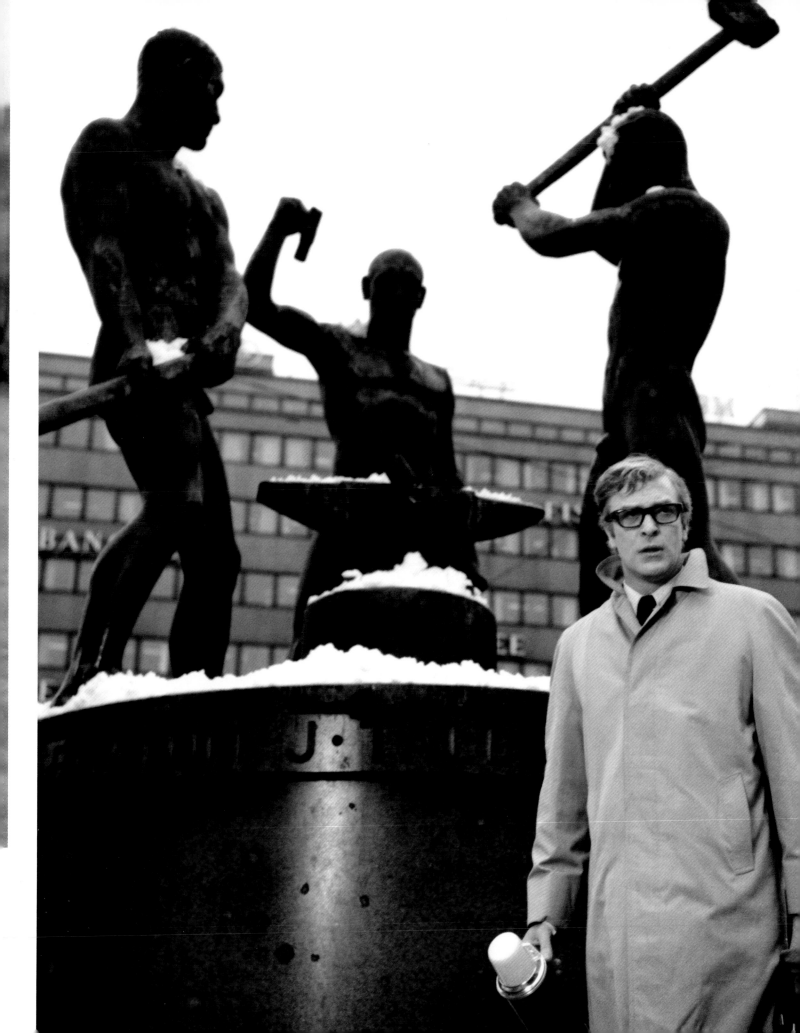

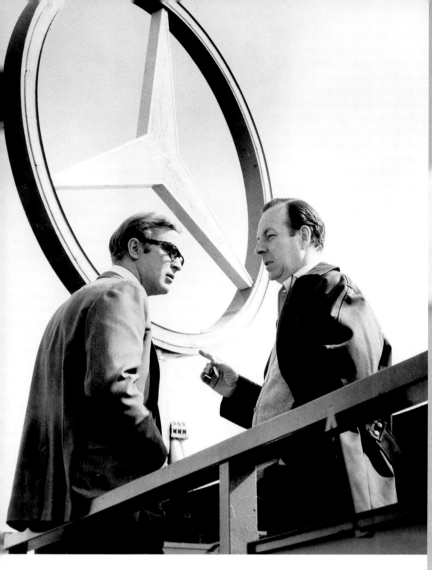

Guy Hamilton, director of **FUNERAL IN BERLIN**, discusses a
scene with Michael Caine shot on the observation platform at the
Daimler-Benz AG building in Berlin.

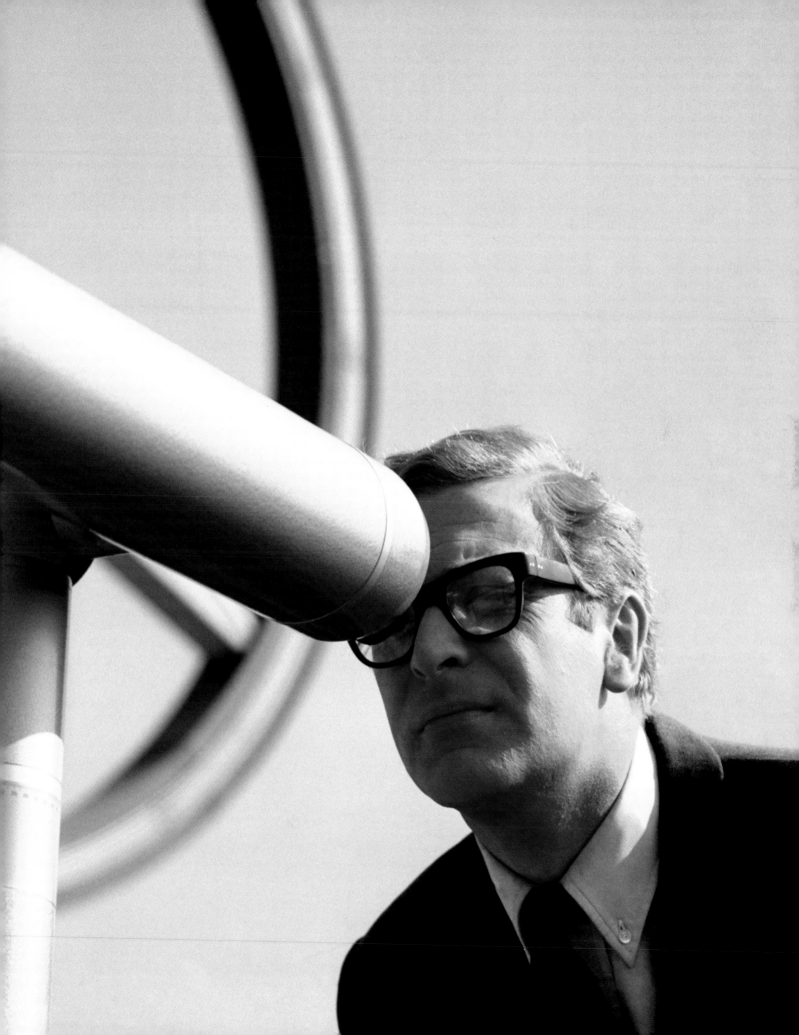

billion dollar brain
1967

'this is the first time i've had
a russian spy on room service.'

harry palmer

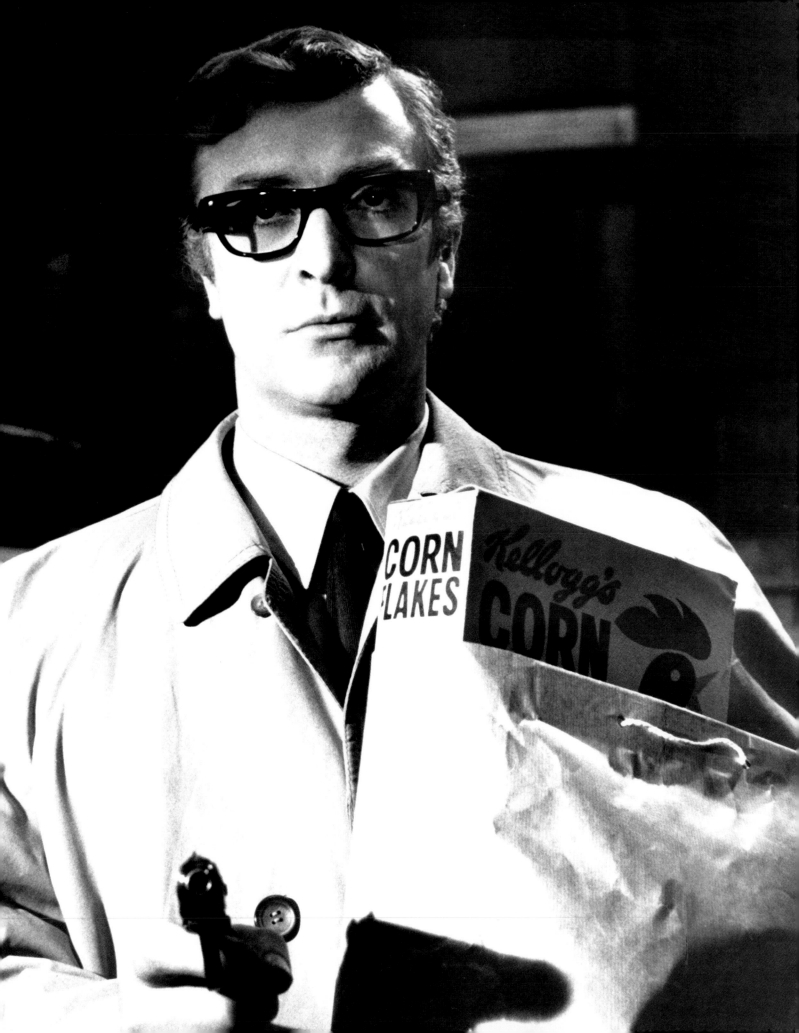

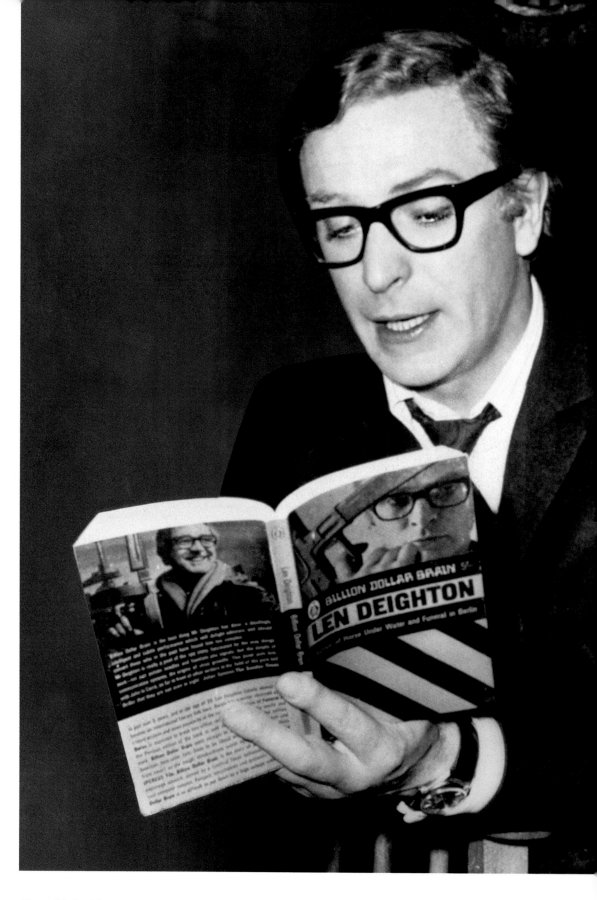

Above: Michael Caine reads all about his alter-ego Harry Palmer
in Len Deighton's novel, **BILLION DOLLAR BRAIN**.
Opposite: Harry Palmer is relieved not to be the Russian target.

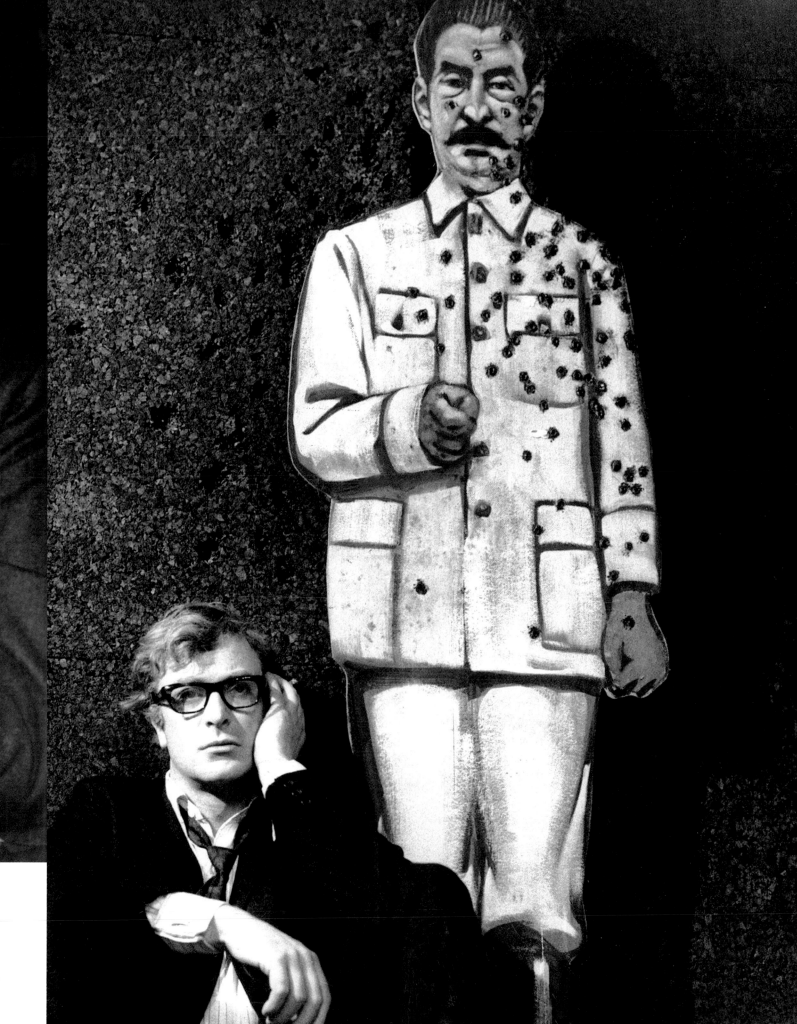

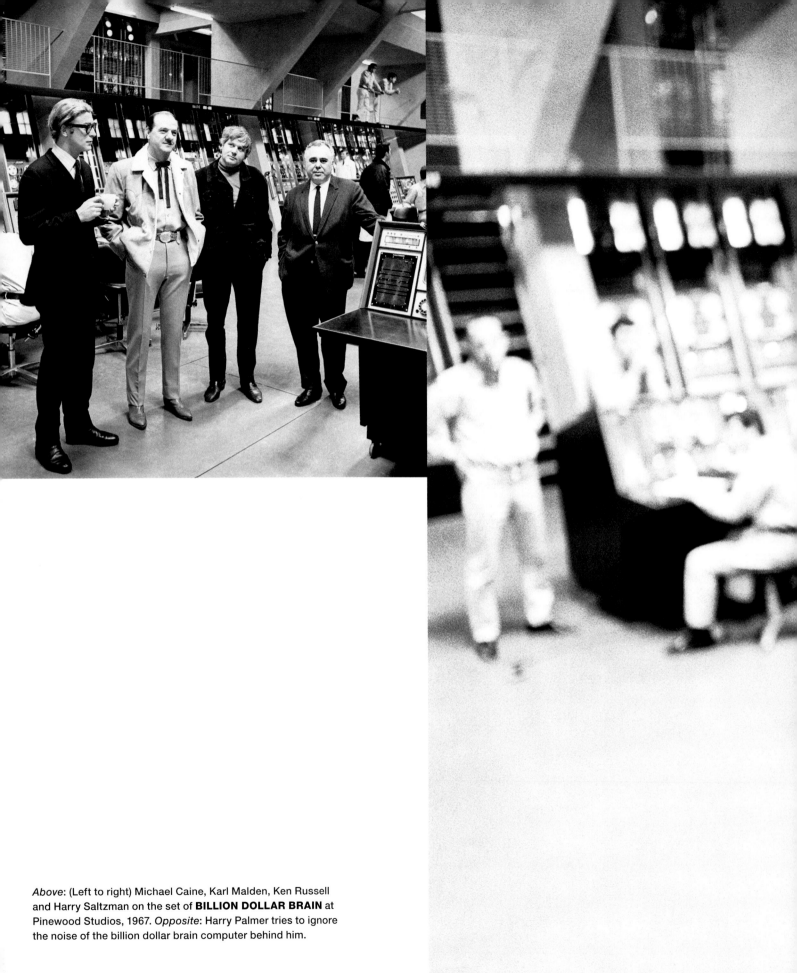

Above: (Left to right) Michael Caine, Karl Malden, Ken Russell and Harry Saltzman on the set of **BILLION DOLLAR BRAIN** at Pinewood Studios, 1967. *Opposite*: Harry Palmer tries to ignore the noise of the billion dollar brain computer behind him.

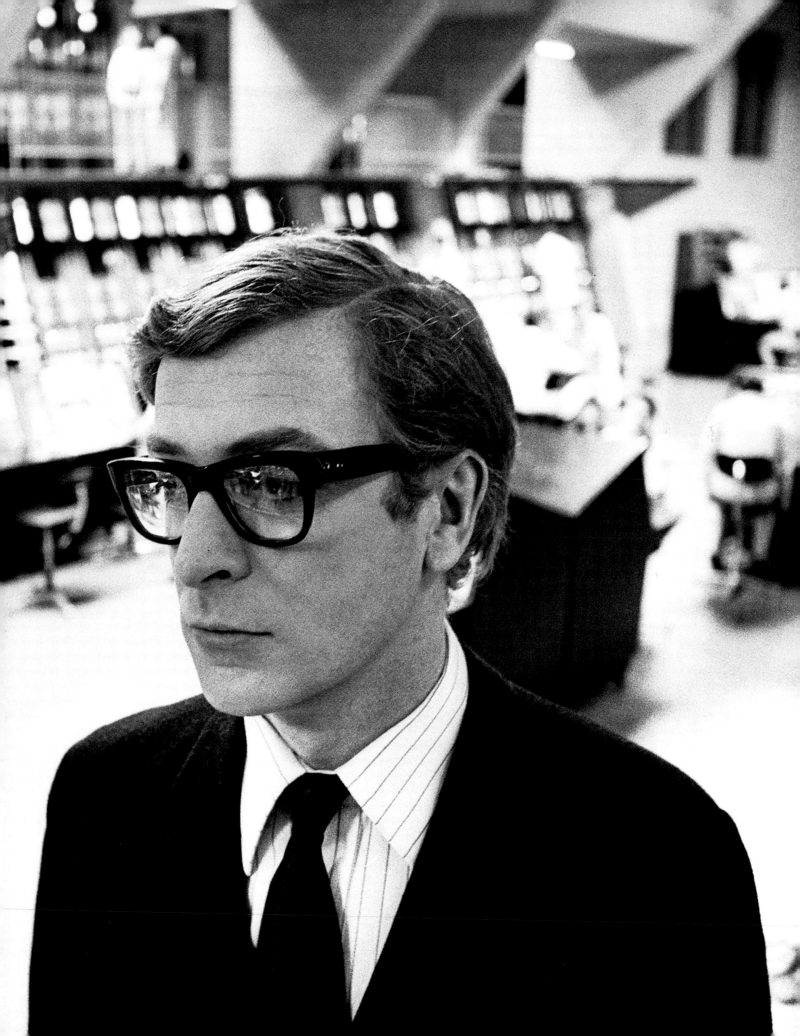

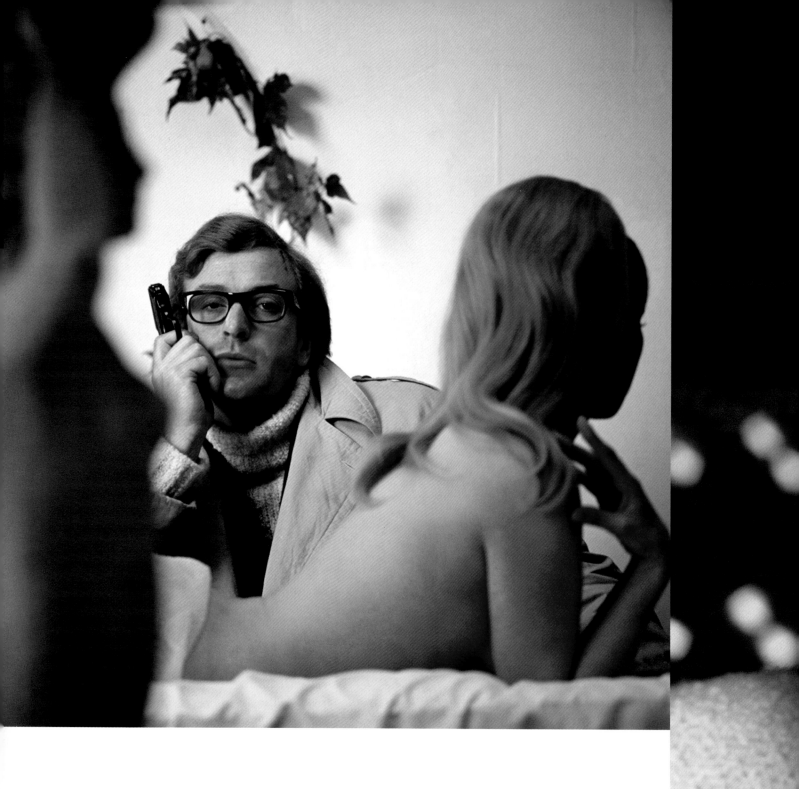

Publicity photographs taken by Douglas Kirkland to promote the movie
BILLION DOLLAR BRAIN, 1967.

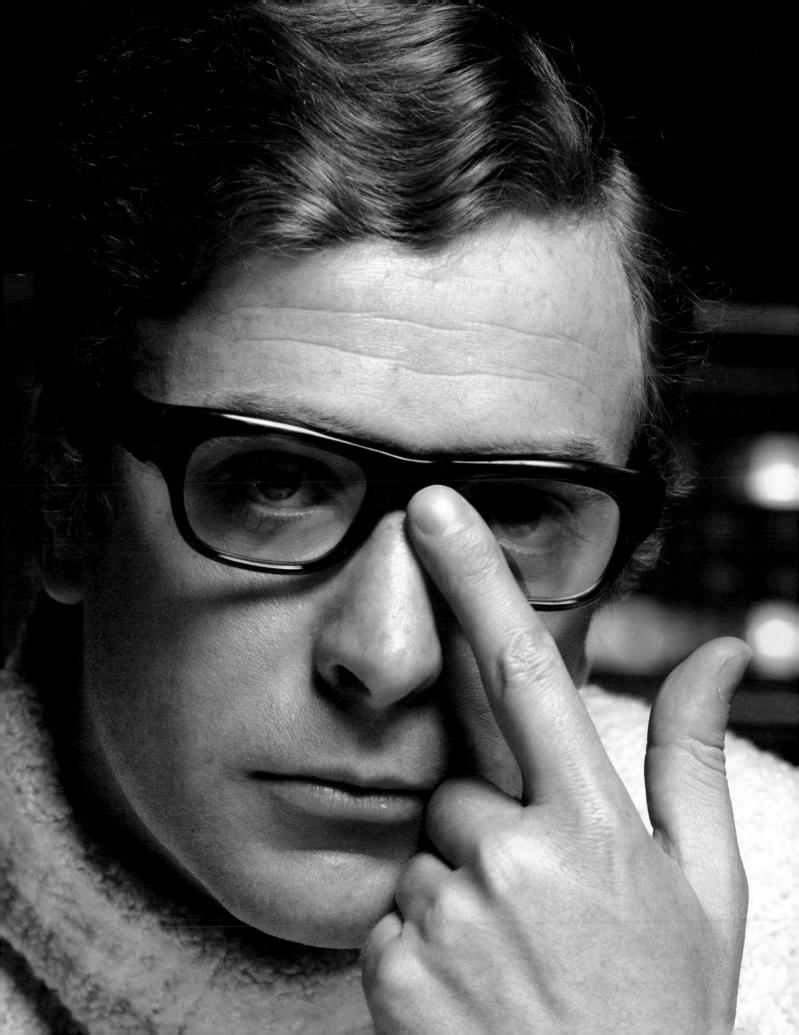

on set

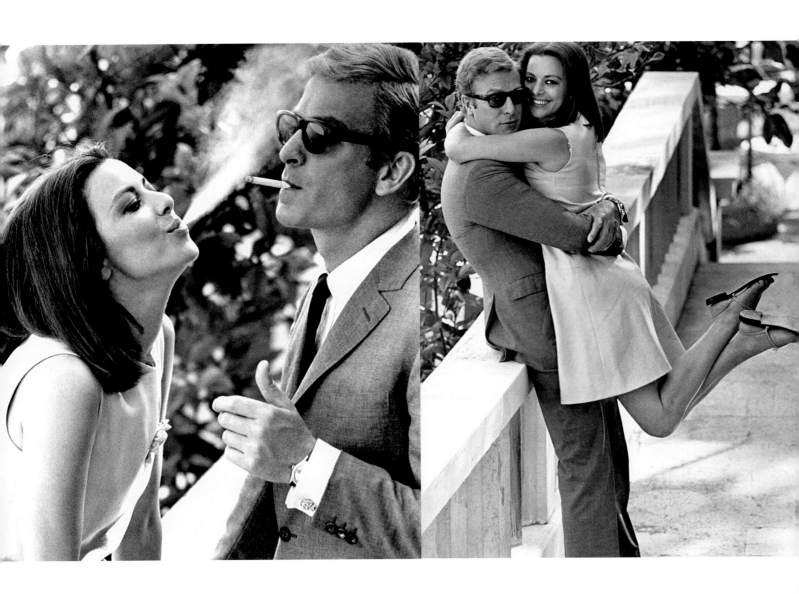

Above and *opposite*: Michael Caine and Italian co-star Giovanna
Ralli get to know one another on the set of the 1968 movie **DEADFALL**.
Overleaf: On location in Greece, Caine works his usual magic on co-star
Anna Karina in the 1968 movie **THE MAGUS**.

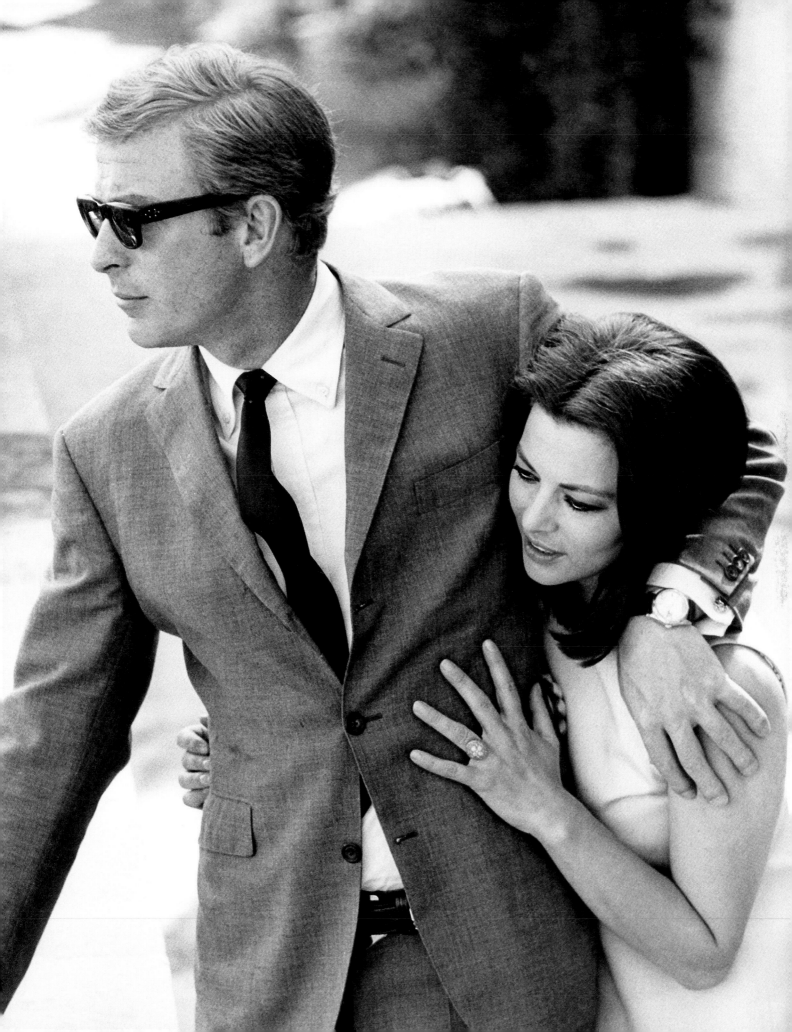

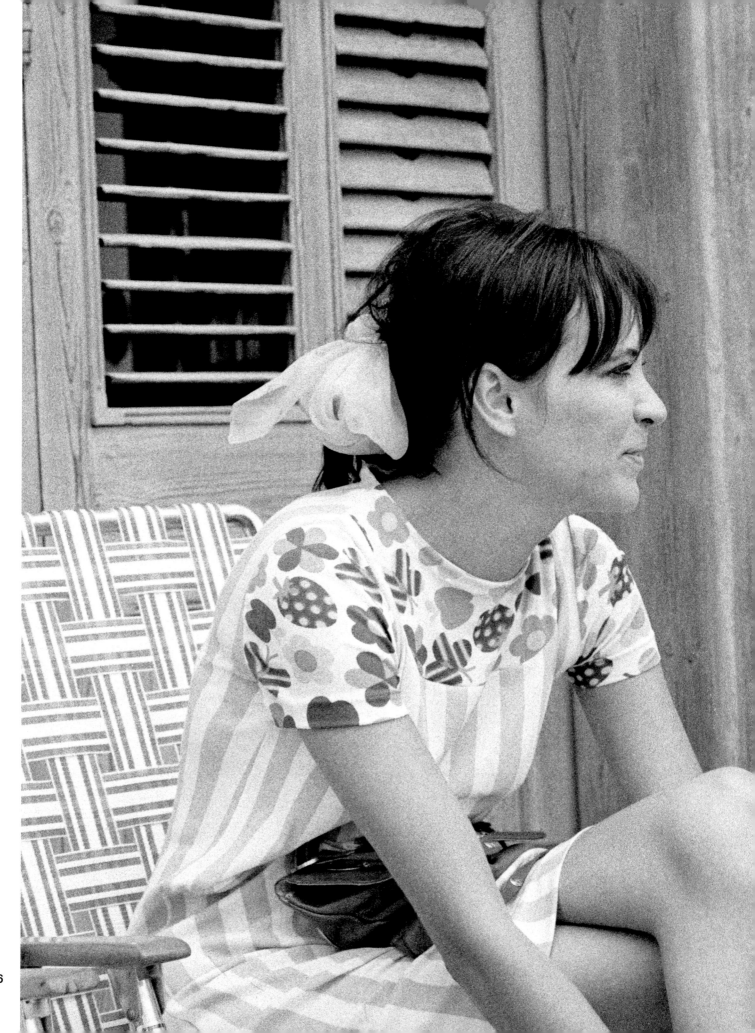

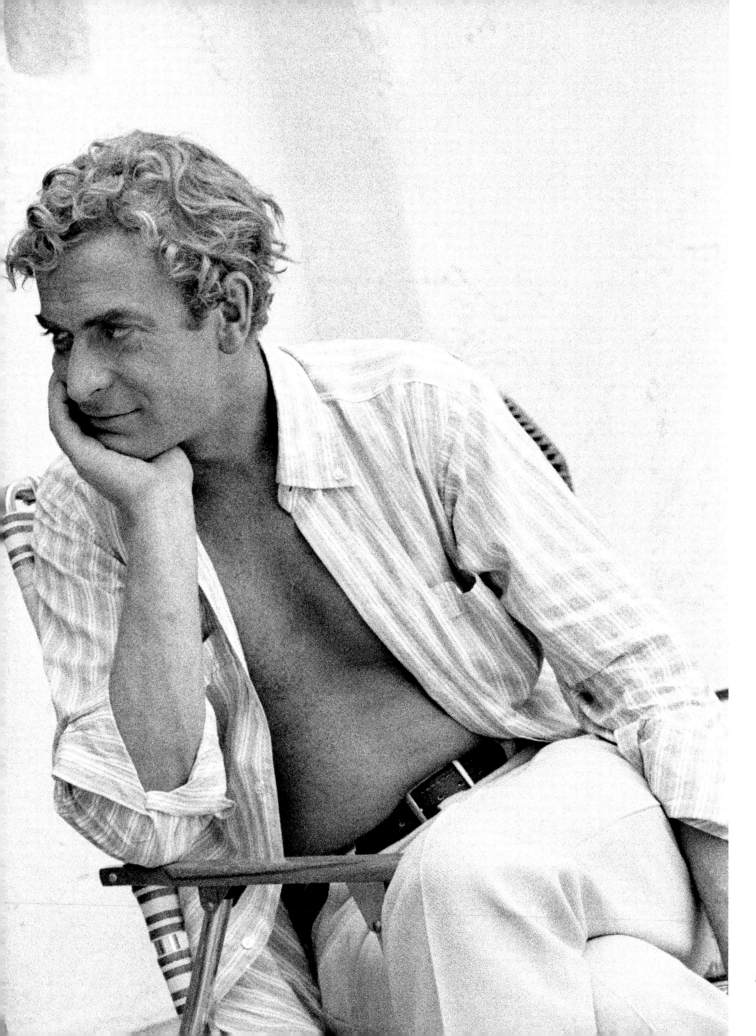

the italian job 1969

'you're only supposed to blow the bloody doors off...'

charlie croker

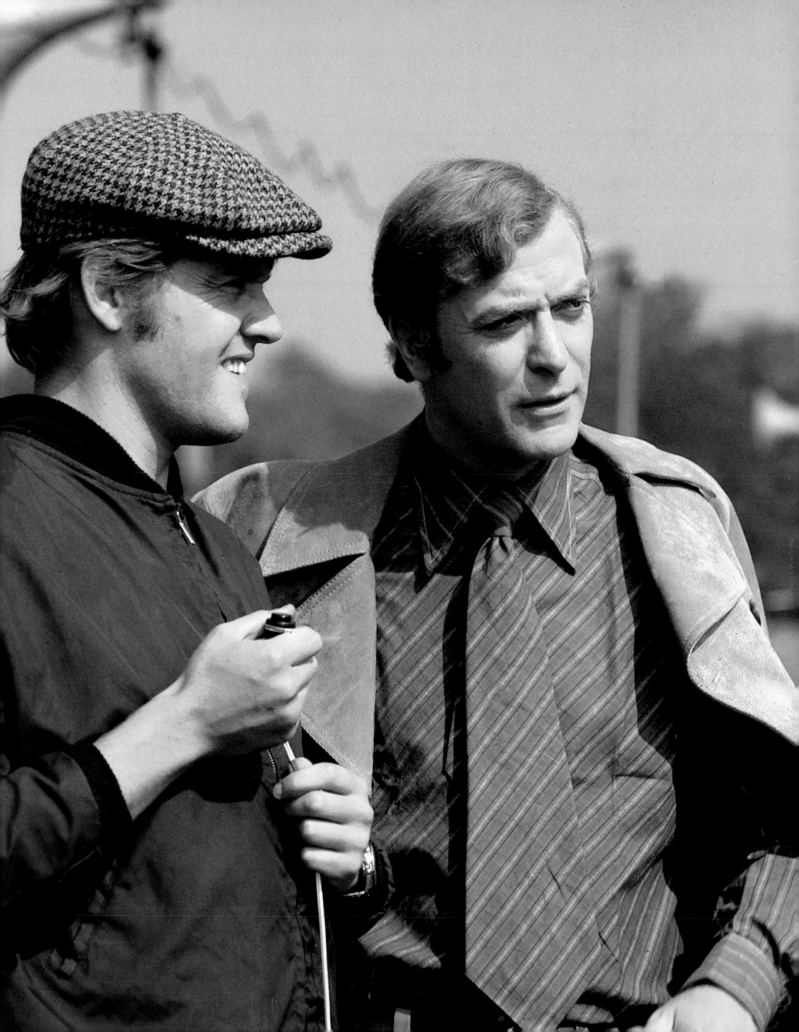

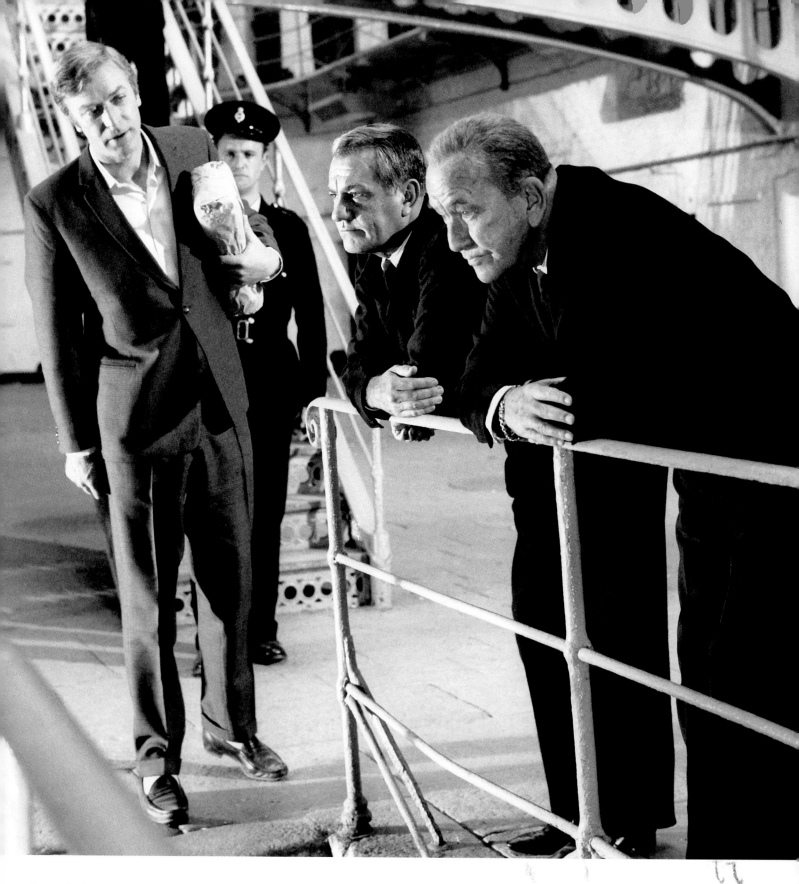

Above: Croker says his goodbyes to Keats and Mr Bridger. Croker
is probably the only man to ever leave prison in a Doug Hayward suit!
Opposite: Noël Coward reminds Caine that in Italy they drive on
the wrong side of the road.

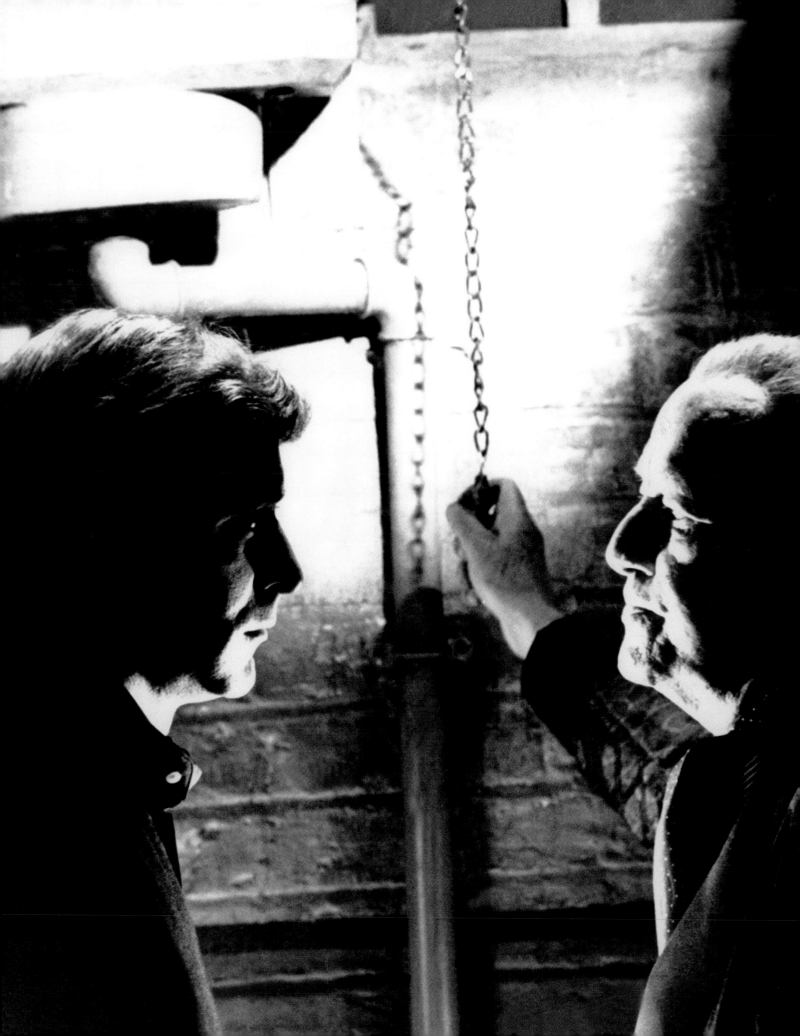

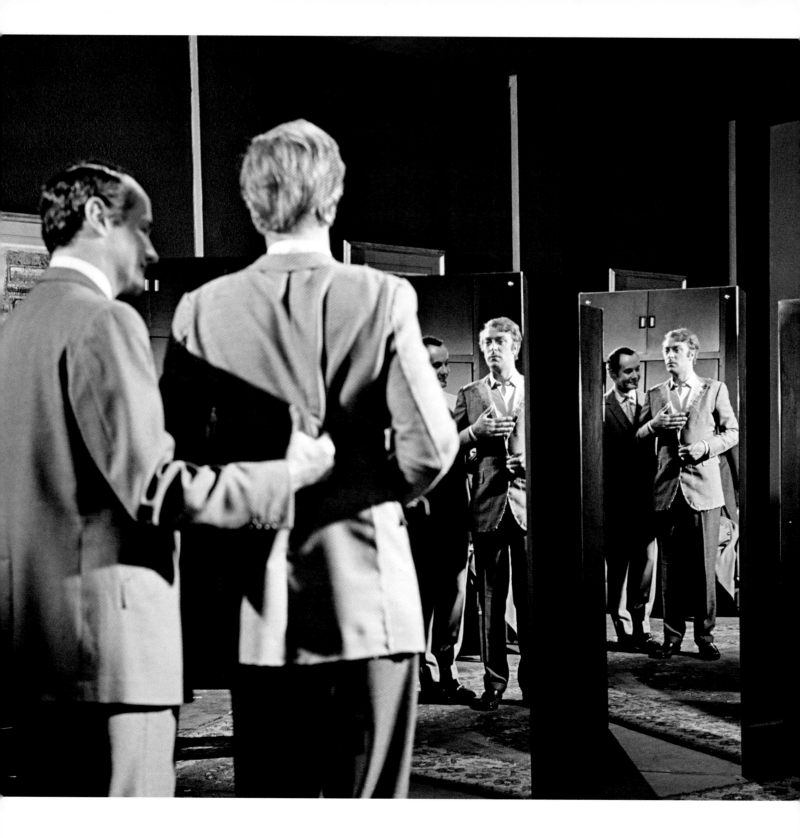

Above: Charlie Croker, out of prison and now a little slimmer, is measured up for a new suit. *Opposite*: Caine to shirtmaker Simon Dee: 'Shorten the sleeves, will you love, I'm not a gorilla...' *Overleaf*: High up on an alpine pass Croker talks his way out of his gang being killed by promising Mafia boss Altabani (Raf Vallone) that the Italian community in Britain will suffer reprisals if anything happens to them.

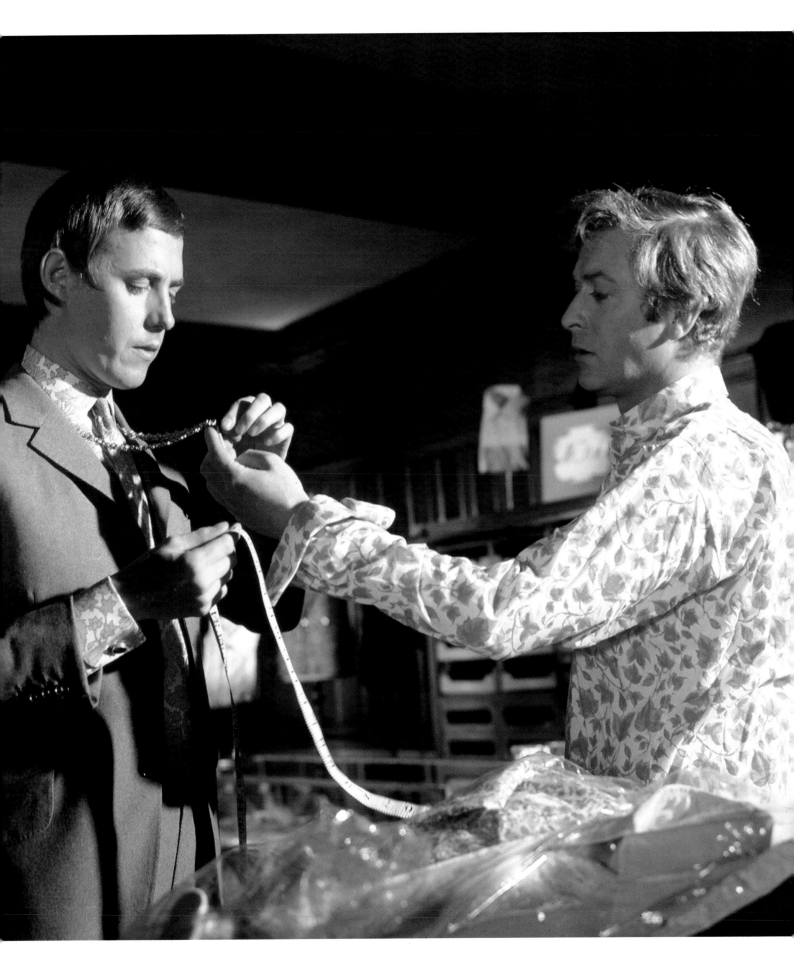

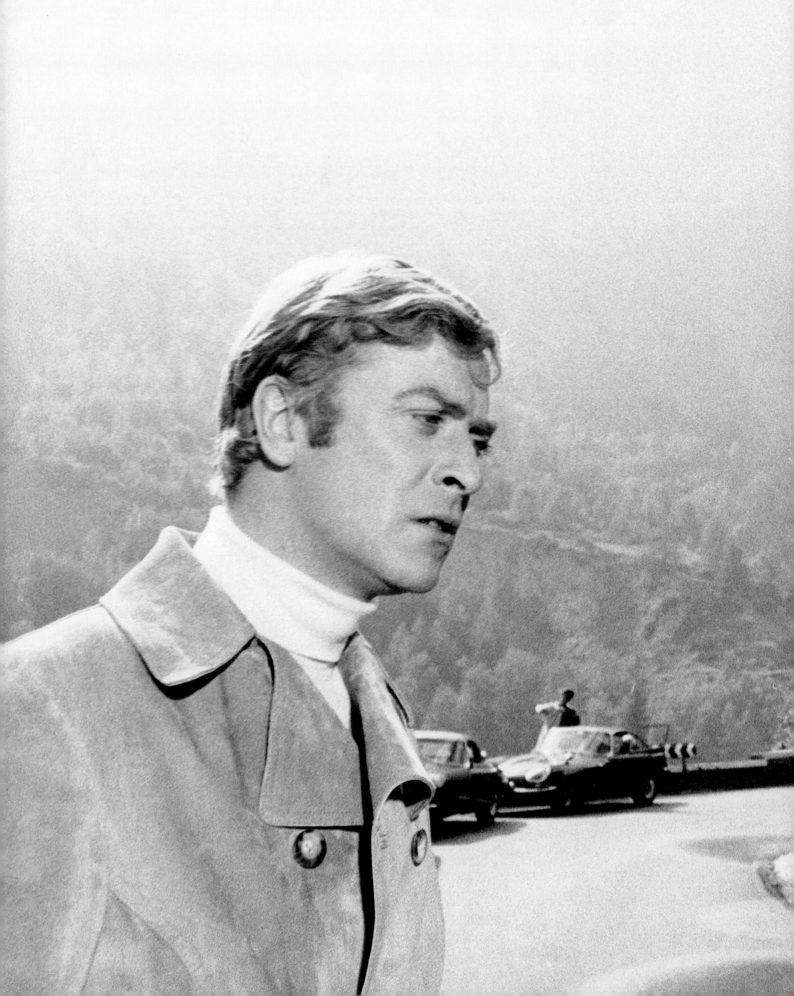

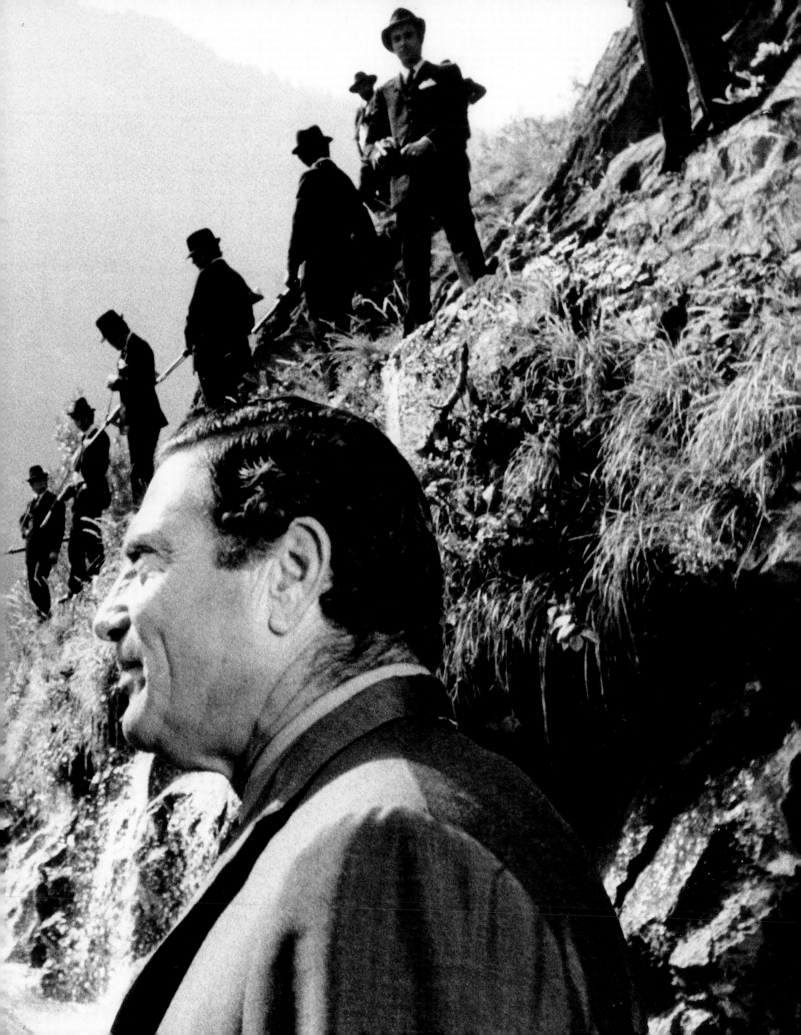

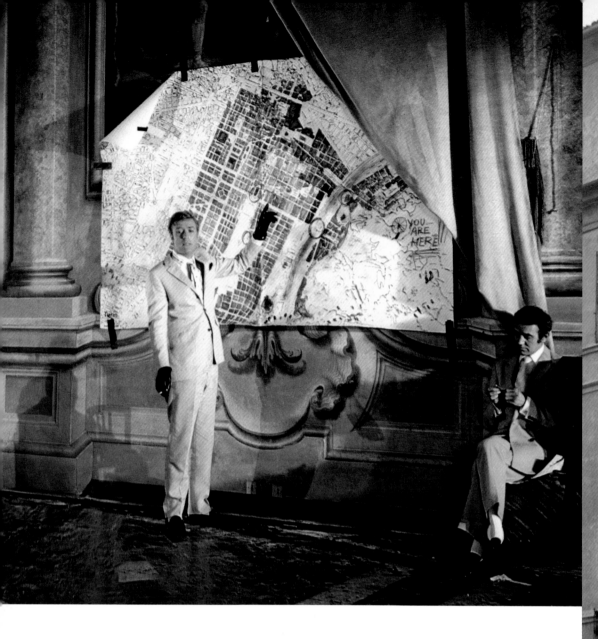

Above: Croker runs over the final escape route from Turin.
Opposite: A group portrait of the cast including the vehicles and
gold bars. *Overleaf*: The red, white and blue Mini Coopers
became the mechanical stars of **THE ITALIAN JOB.**

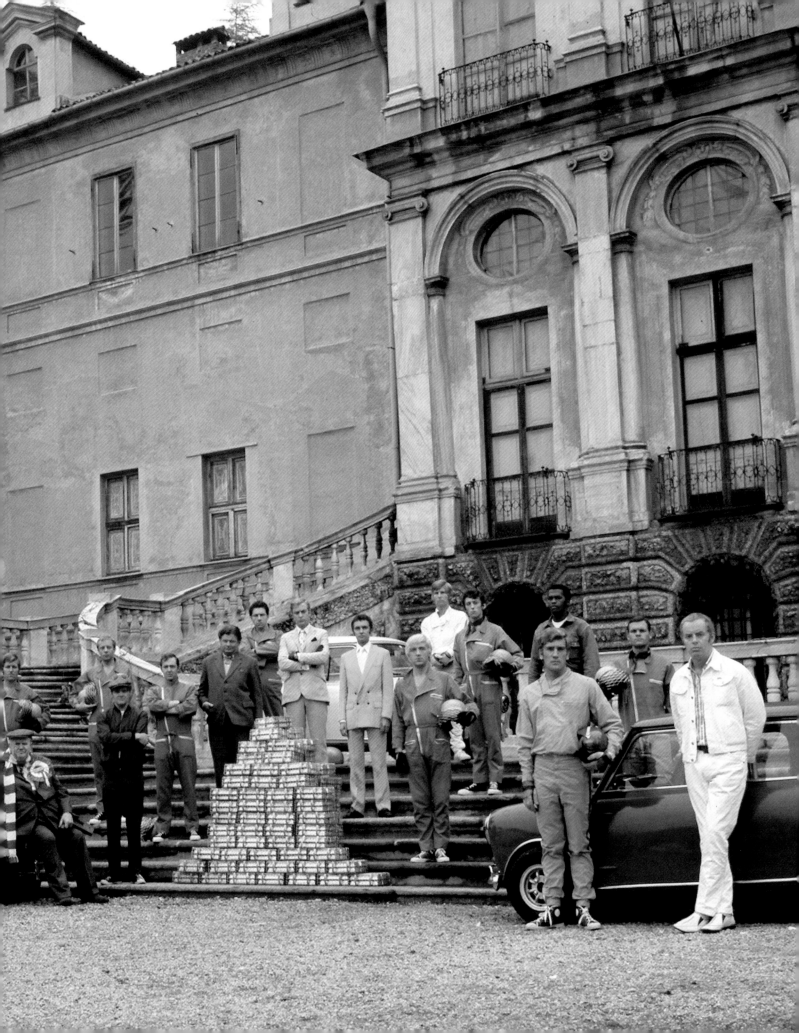

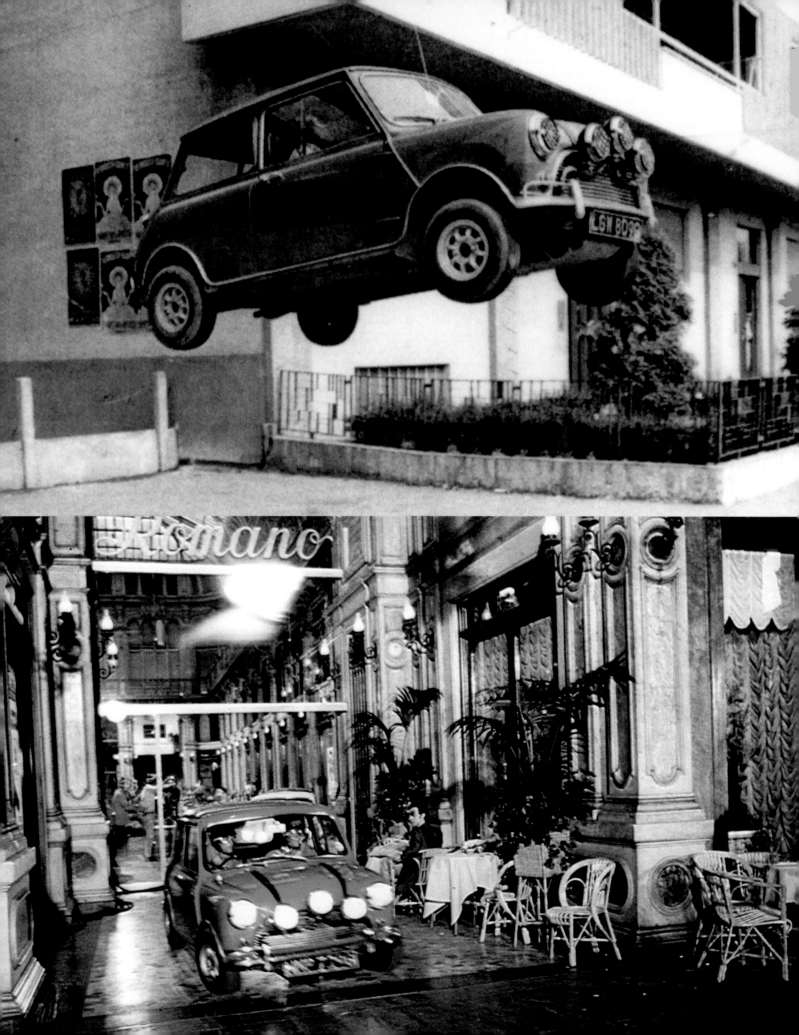

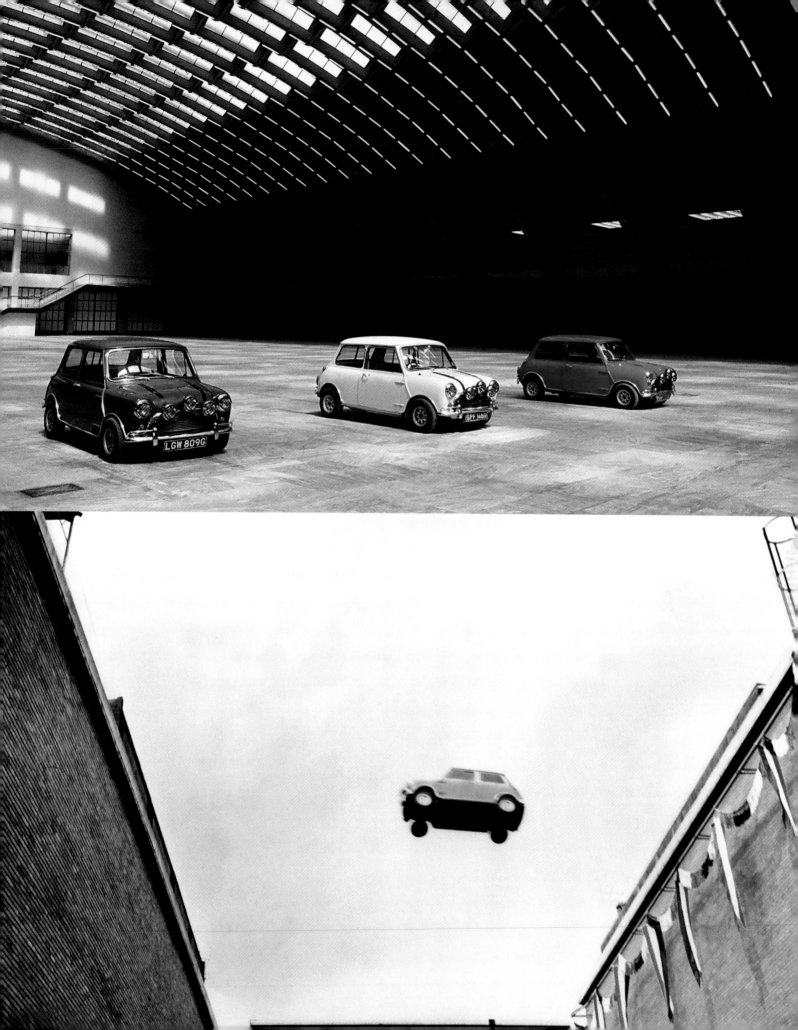

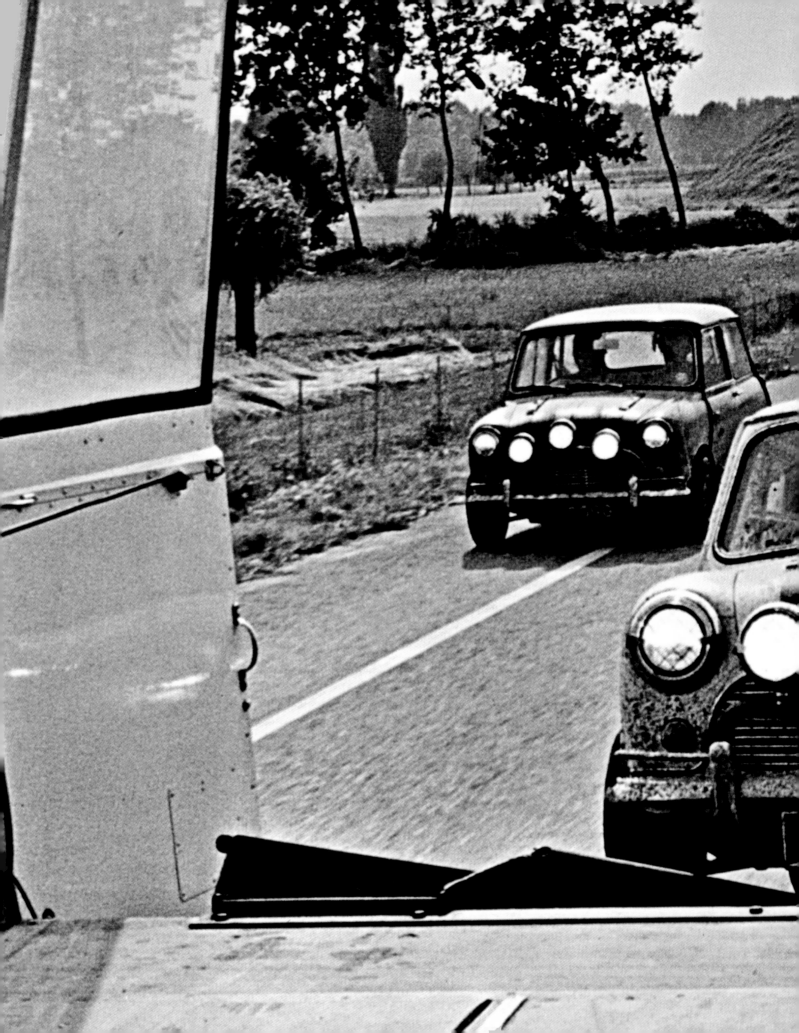

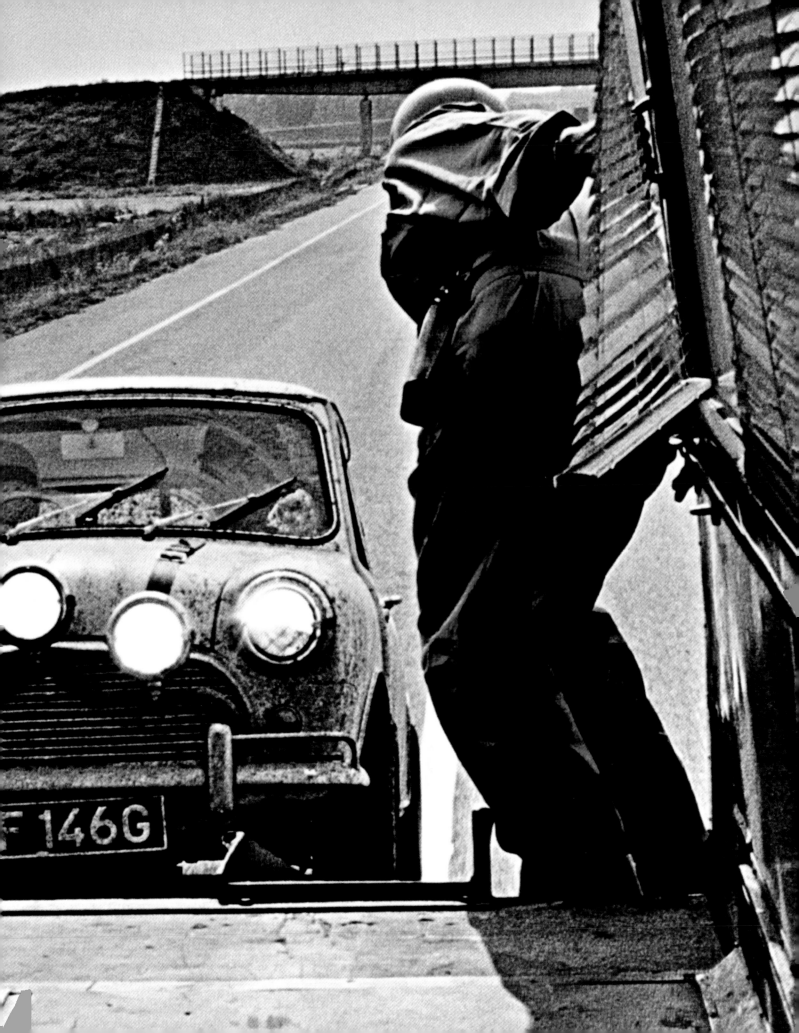

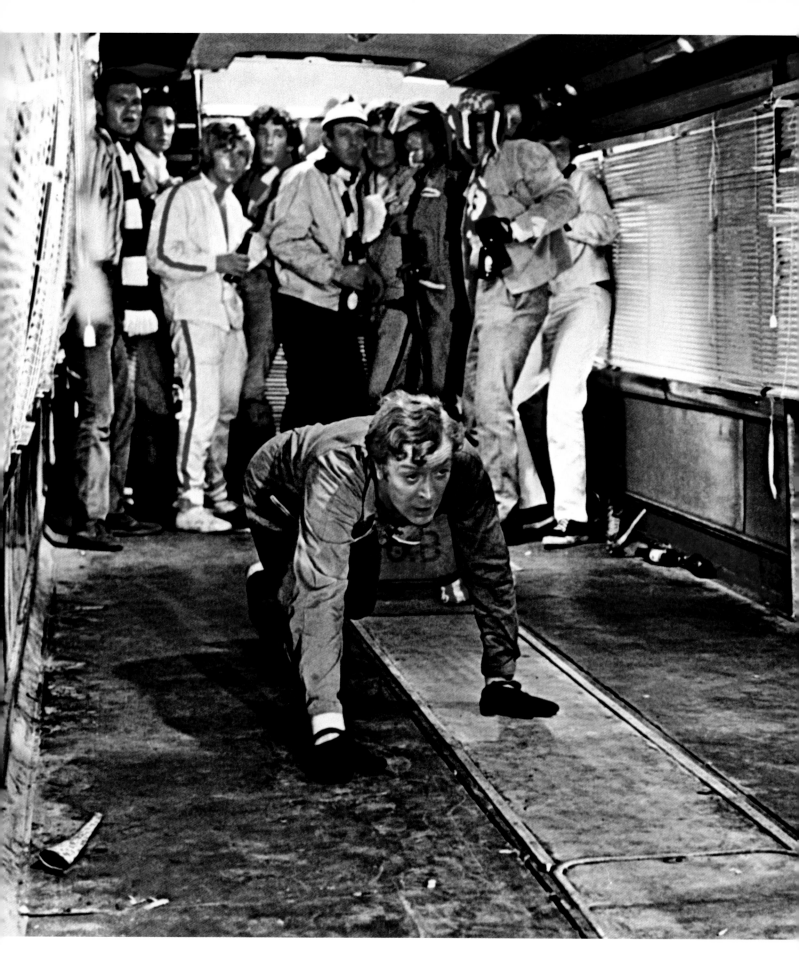

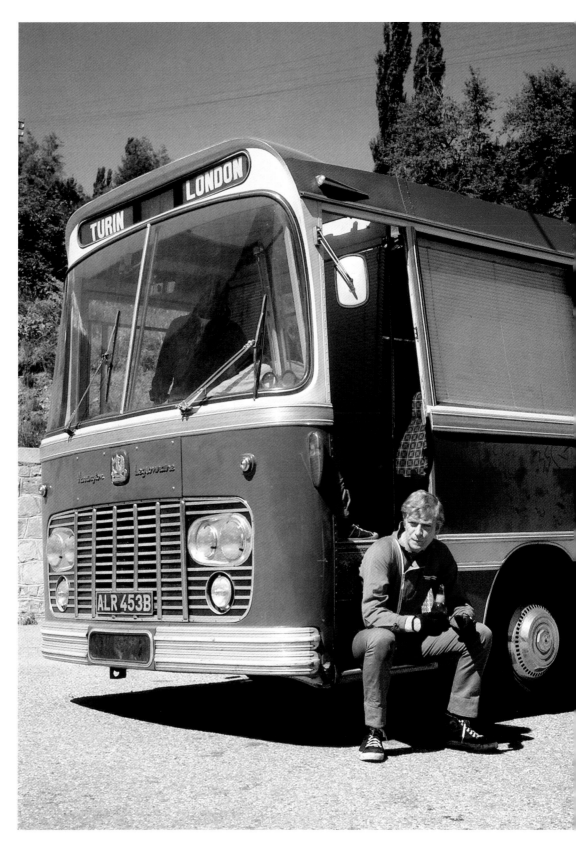

Previous page: 'Get the wheels in line…' The Mini Coopers make their final getaway driving up a ramp into the back of a travelling Bedford coach. *Above*: Michael Caine and *that* Bedford coach. *Opposite*: And to the final cliffhanger when Charlie Croker utters the immortal line, 'Hang on a minute lads – I've got a great idea…'

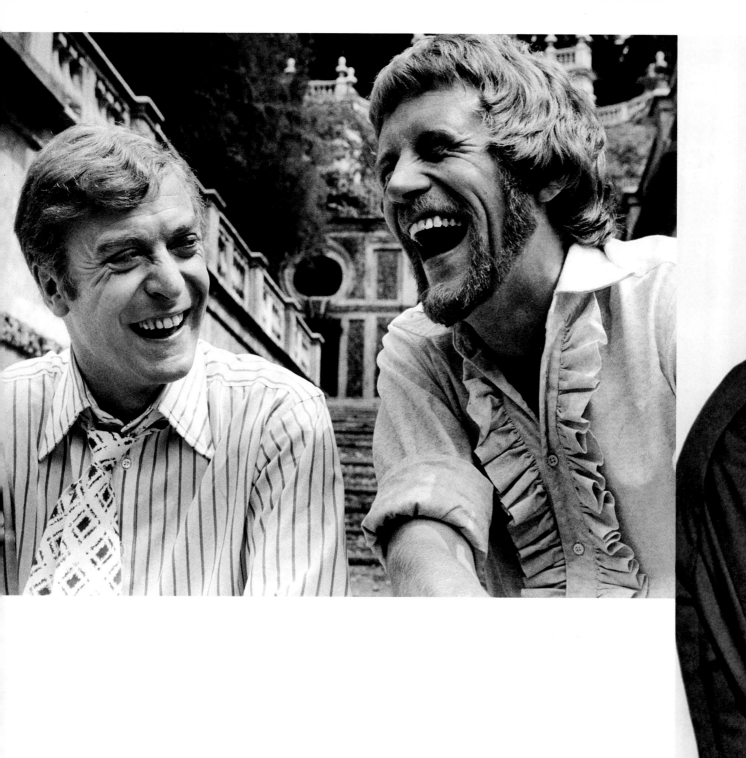

Above: Michael Caine shares a joke with director Peter Collinson on the set of the 1969 movie **THE ITALIAN JOB**. *Opposite*: Caine and Noël Coward light up after a hard day's work.

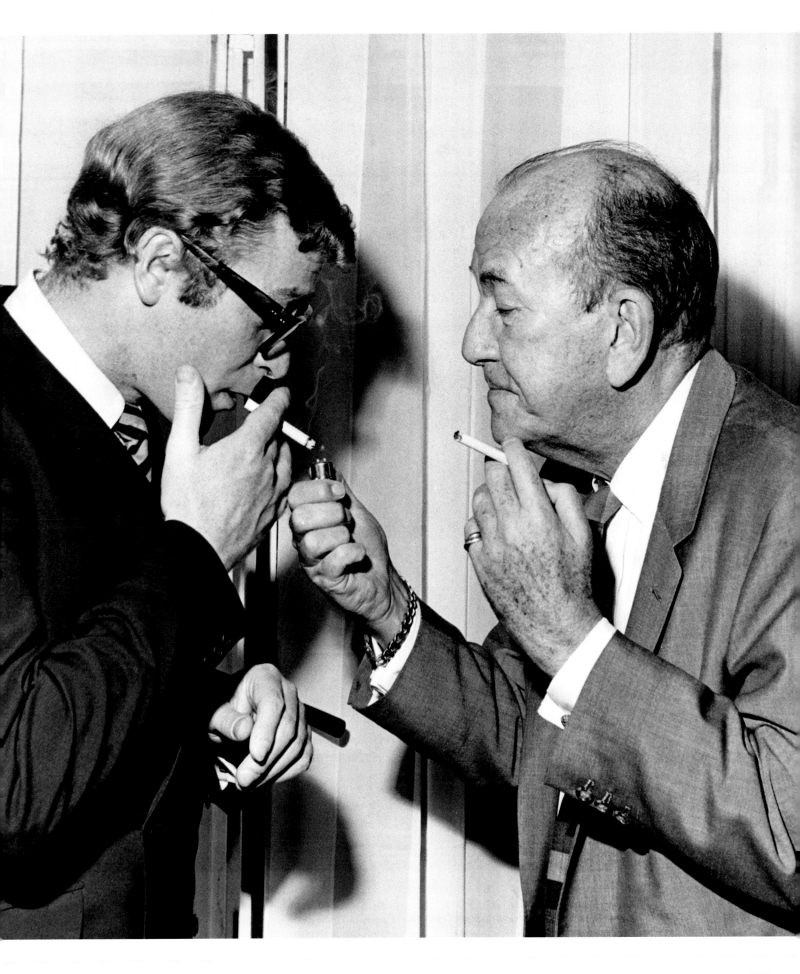

out and about

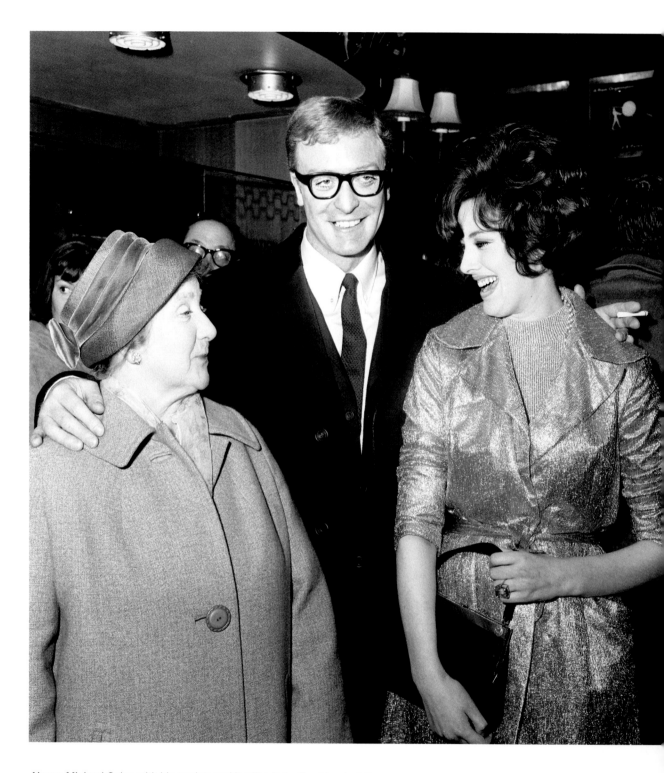

Above: Michael Caine with his mother and leading lady, Sue Lloyd, at the premiere of the movie **THE IPCRESS FILE**, 1965. *Opposite*: Caine at the Variety Club Awards luncheon with Barbara Ferris (left) and Anna Neagle, 1967.

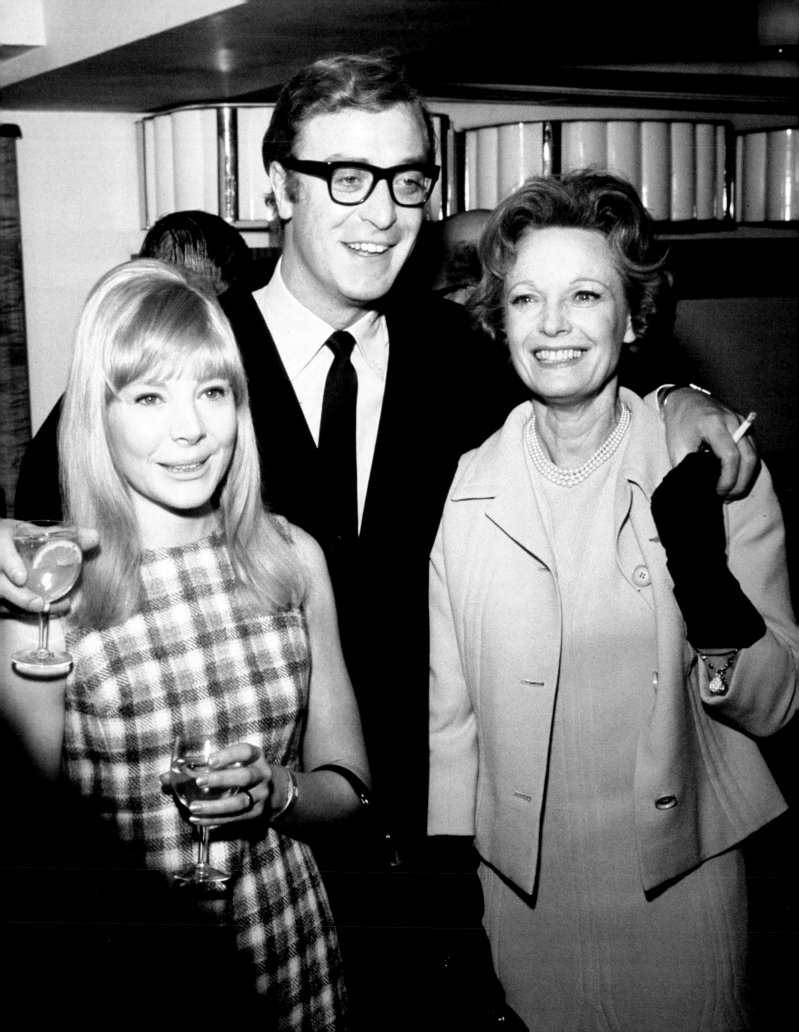

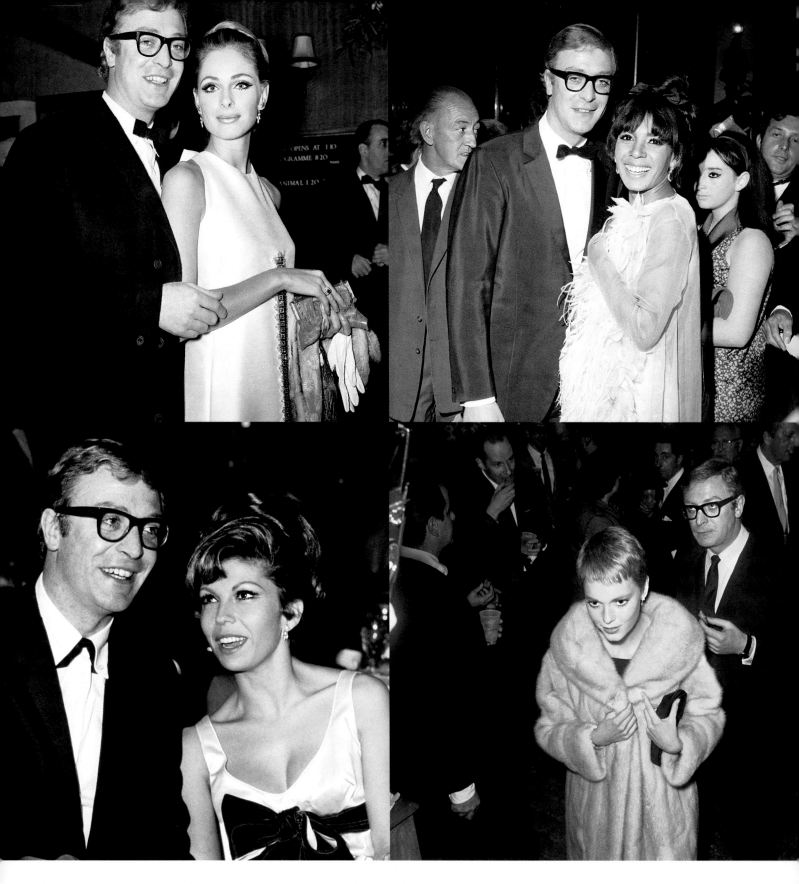

Above: The 'In' Crowd. Michael Caine with (clockwise from top left): Camilla Sparv at the premiere of **MURDERERS' ROW** at Leicester Square Theatre, 1967; Shirley Bassey at the premiere of **HURRY SUNDOWN** at the Plaza, 1967; Mia Farrow at a 20th Century Fox party in Los Angeles, 1966; Nancy Sinatra at the premiere party for **THE SPY WHO CAME IN FROM THE COLD** in Hollywood, 1965. *Opposite*: Taking it easy! Mr Caine and French actress, Elizabeth Ercy, relaxing in a groovy 1960s apartment.

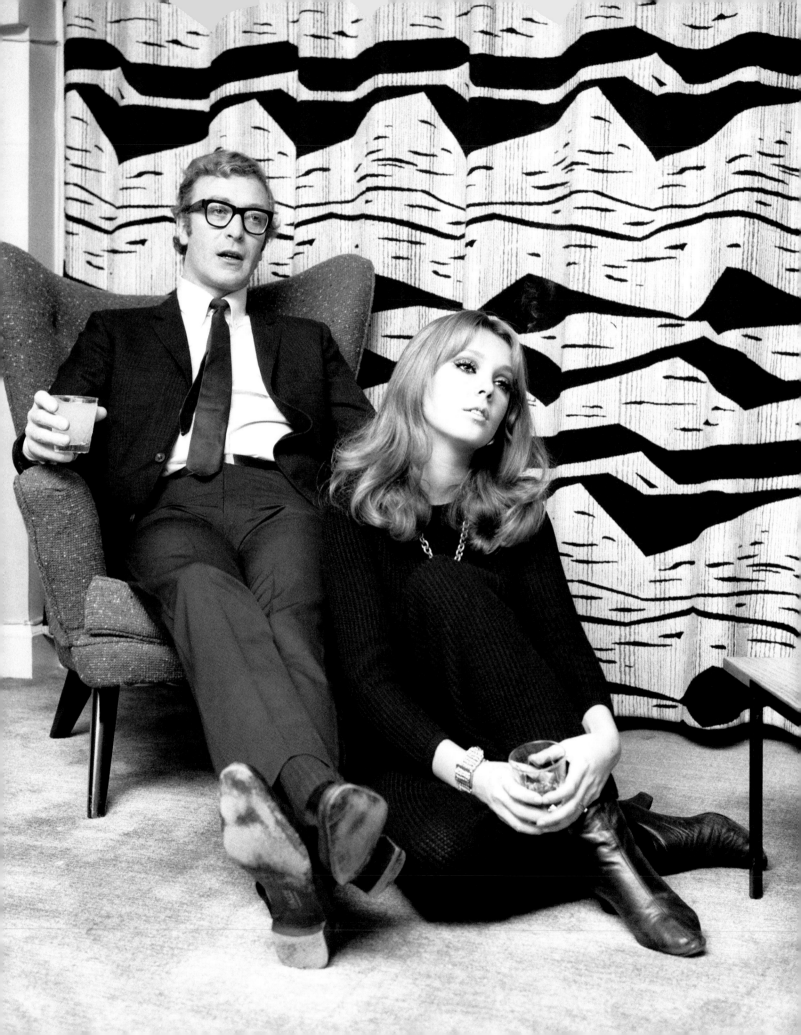

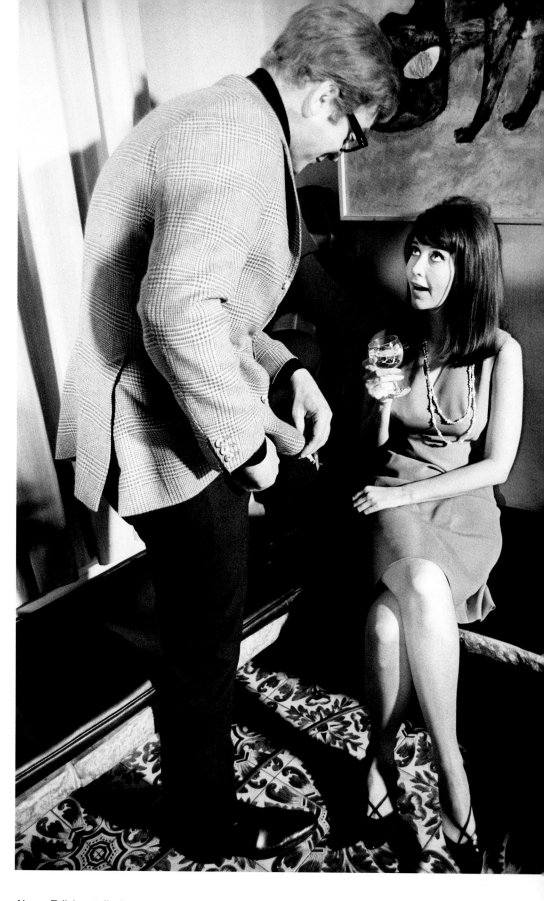

Above: Talk low, talk slow and don't say too much. Michael Caine with
Anjanette Comer at a reception for the movie **FUNERAL IN BERLIN**, 1966.
Opposite: Caine and folk singer Julie Felix at a party, 1967.

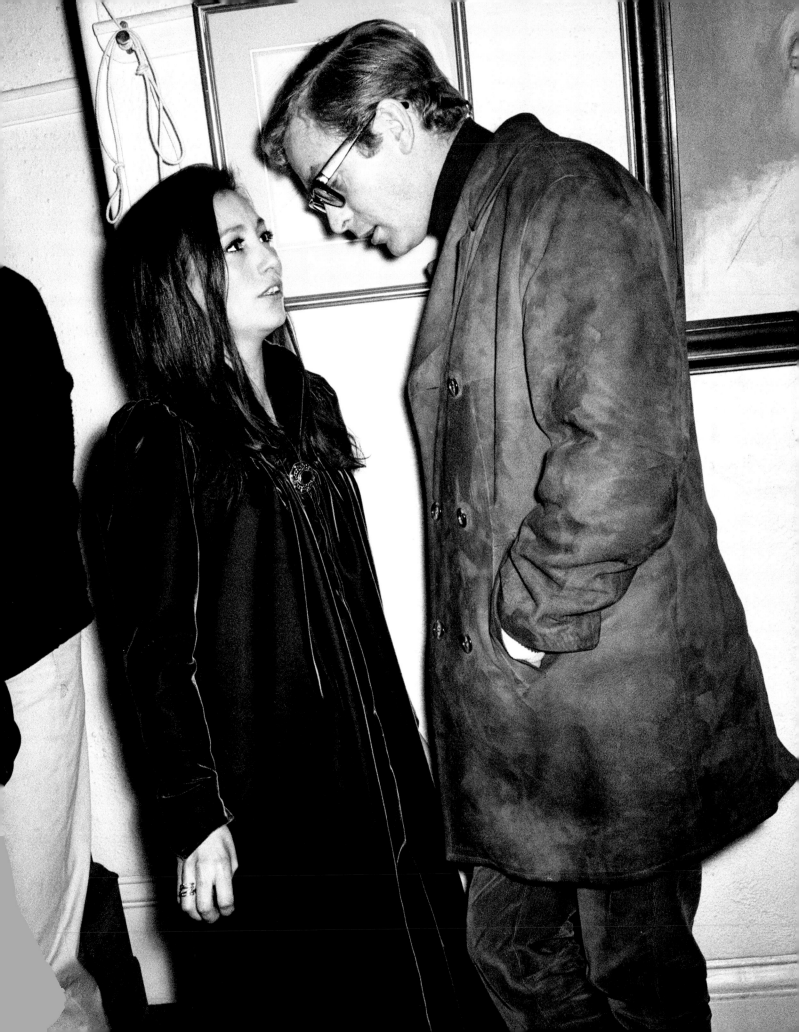

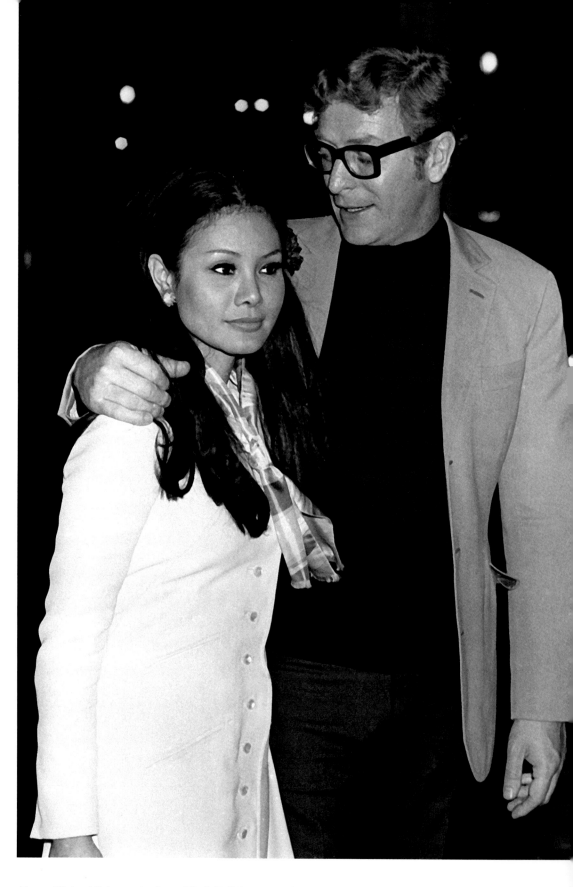

Above: Michael Caine and actress Minda Feliciano attend a
party at Peter Lawford's home in London, 1969. *Opposite*: London calling.
Charlie Croker, aka Michael Caine, and Bianca Pérez-Mora Macias,
who later became Mrs Jagger, on the set of **THE ITALIAN JOB**, 1969.

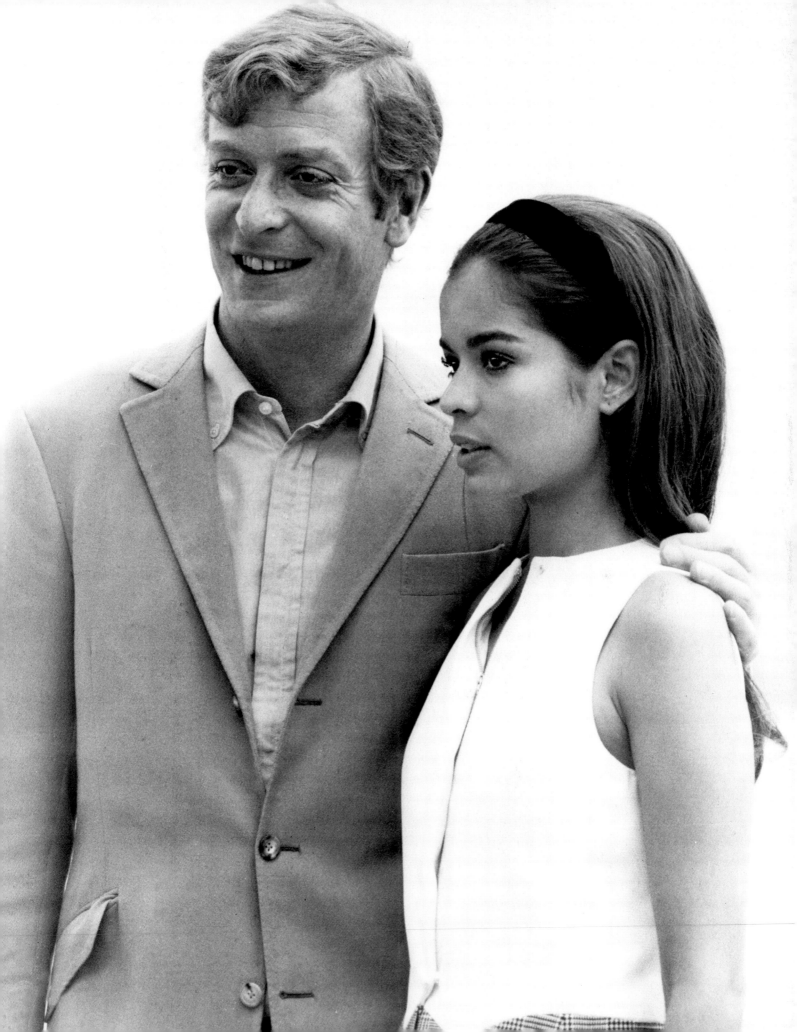

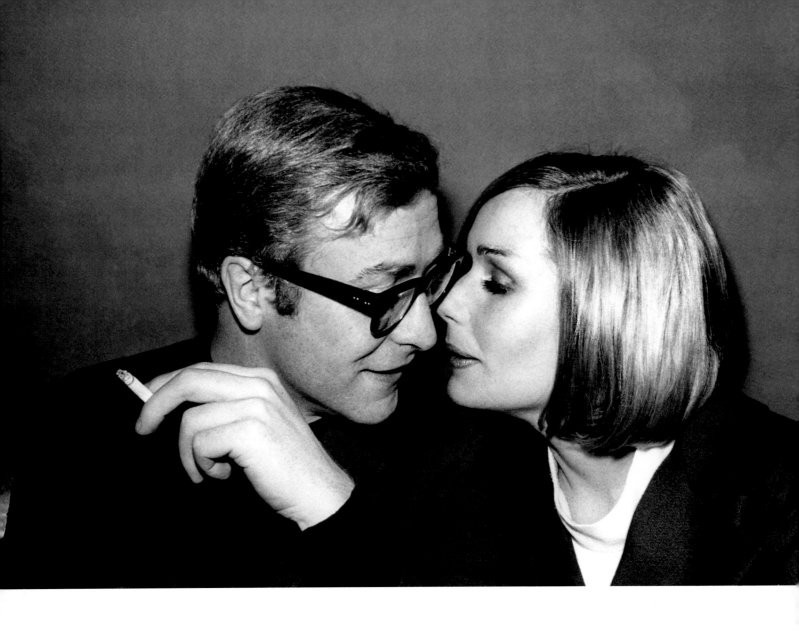

Above: Michael Caine with Sally Kellerman, better known as Major 'Hotlips'
Houlihan of MASH fame, mid-1960s. *Opposite*: Roman Holiday. On the set of the 1968
movie **ROSEMARY'S BABY**, with Roman Polanski and actress Luciana Paluzzi.

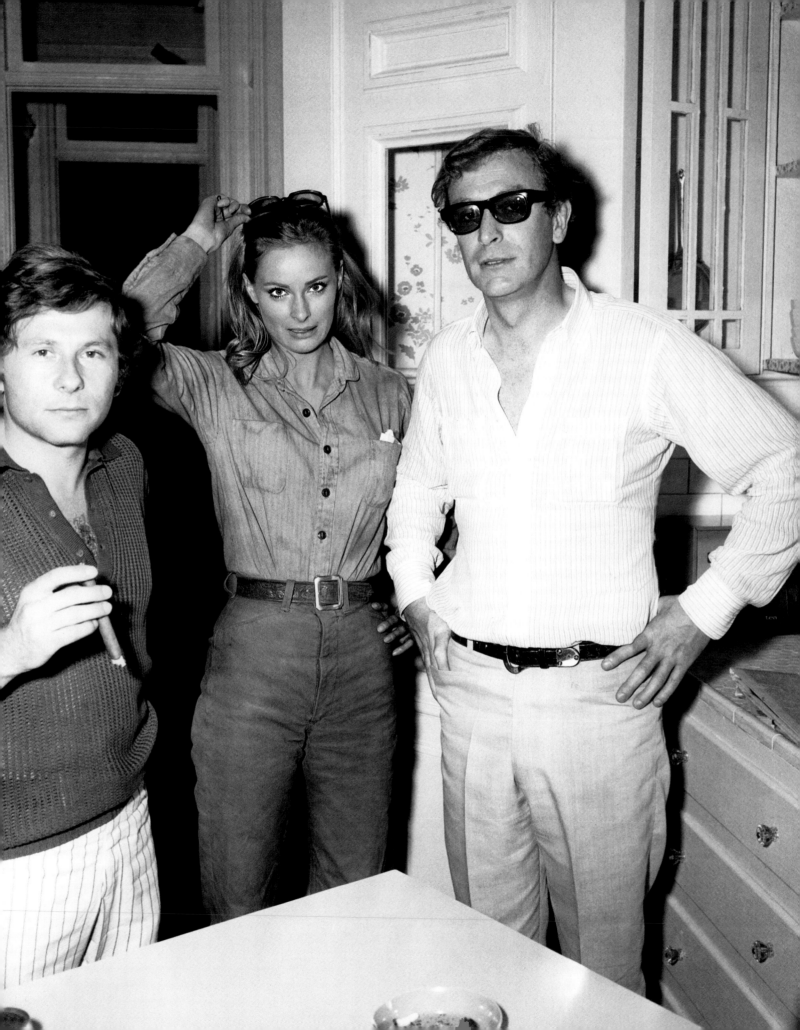

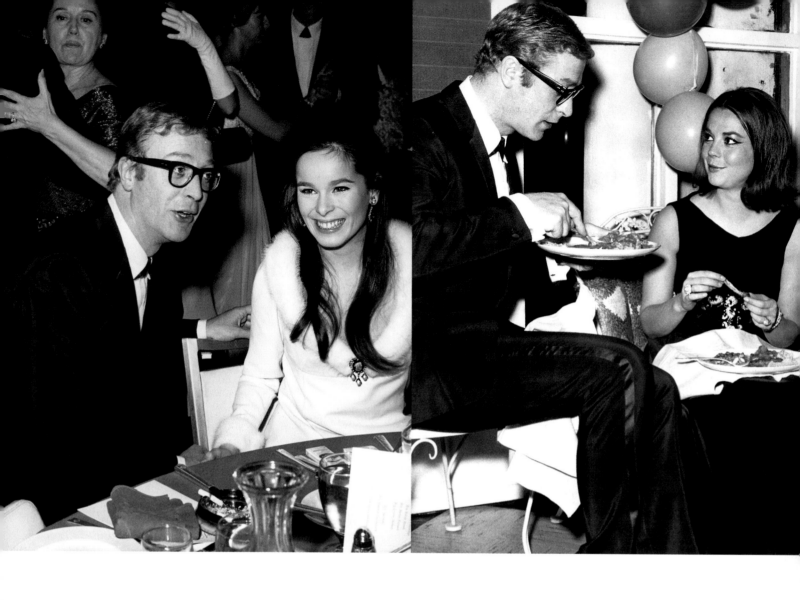

Above left: Michael Caine with actress Geraldine Chaplin at an after-theatre party, 1965. *Above right*: Michael Caine and Natalie Wood at a party in 1966. *Opposite*: Soul meeting. Michael Caine with his wife, Shakira, at the Sherry-Netherland Hotel in New York, 1969.

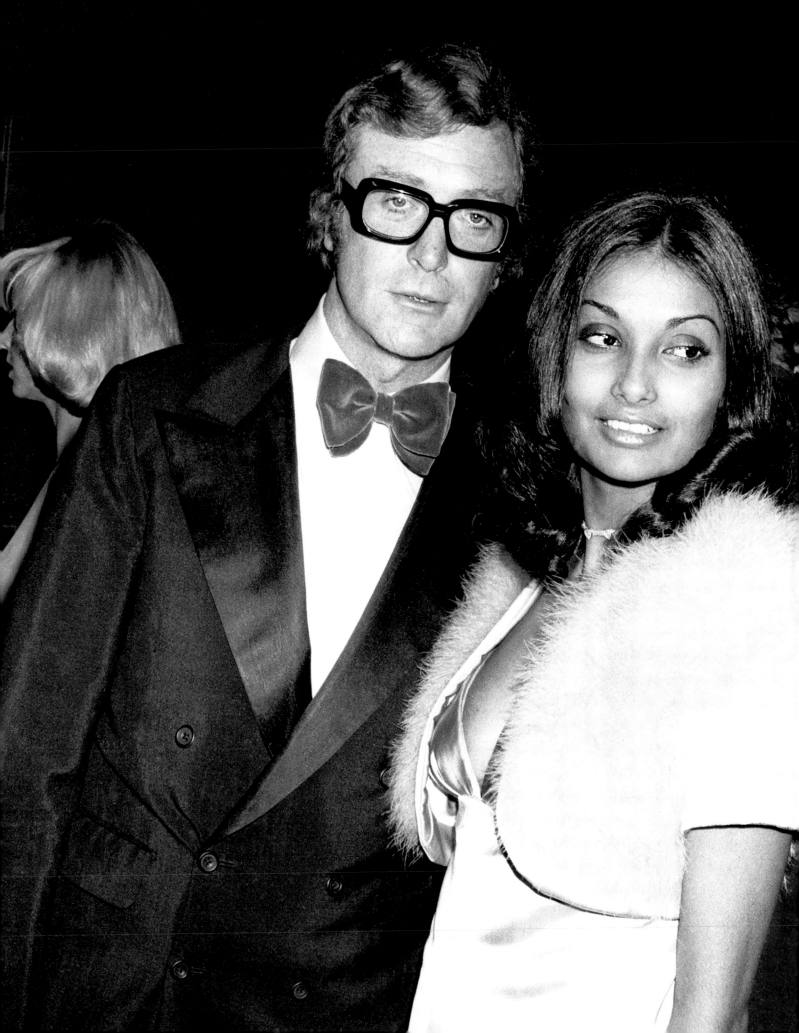

candid caine 1969

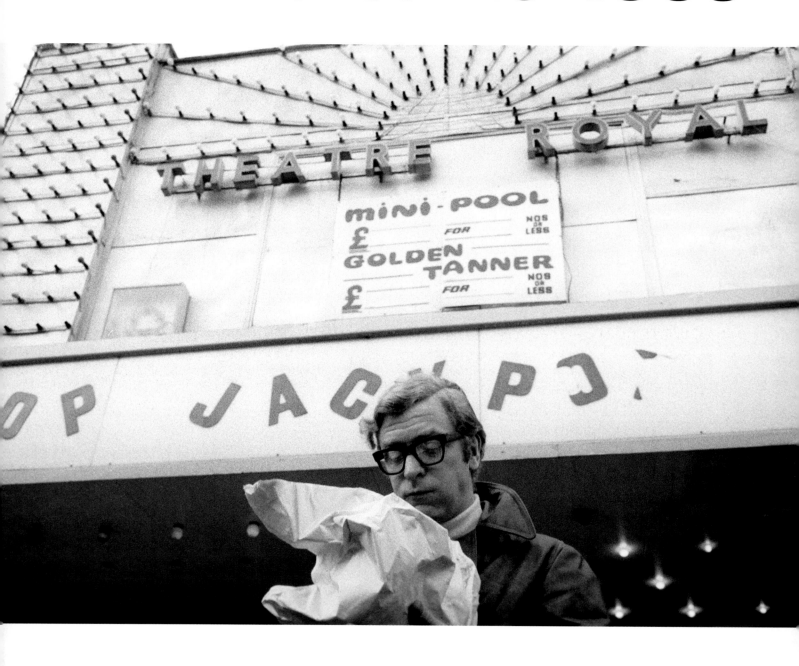

Michael Caine enjoying fish and chips by the seaside.
Photographed in Lowestoft, Suffolk, during an ITV television
documentary, **CANDID CAINE**, 1969.

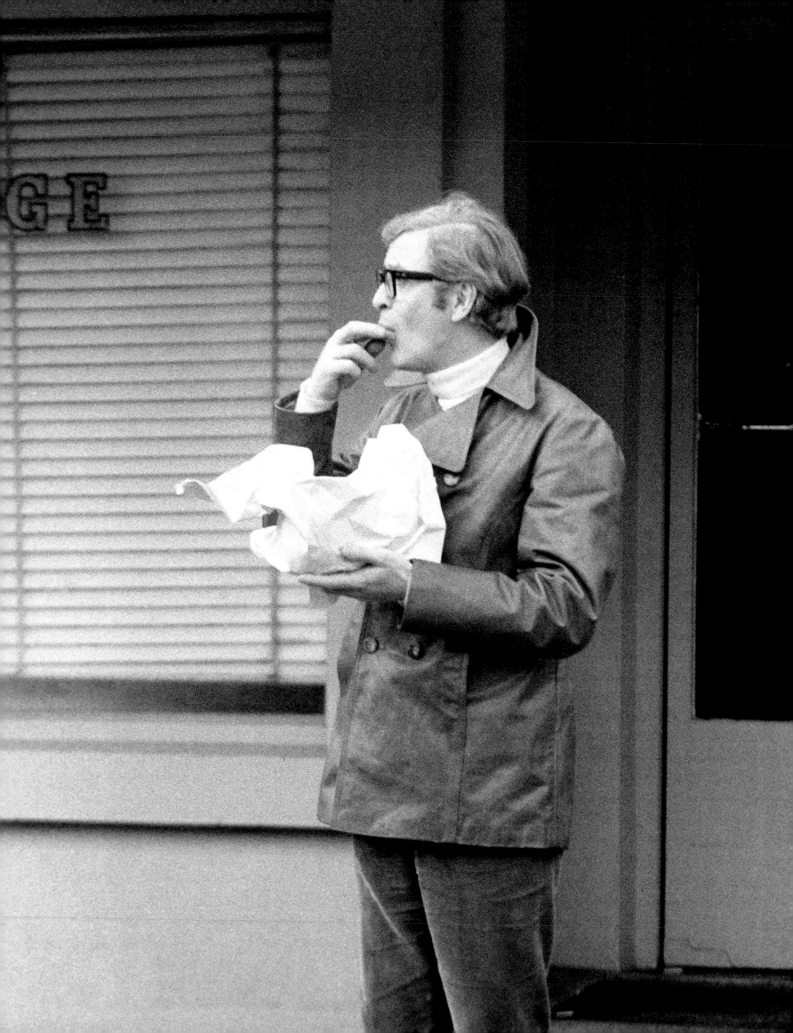

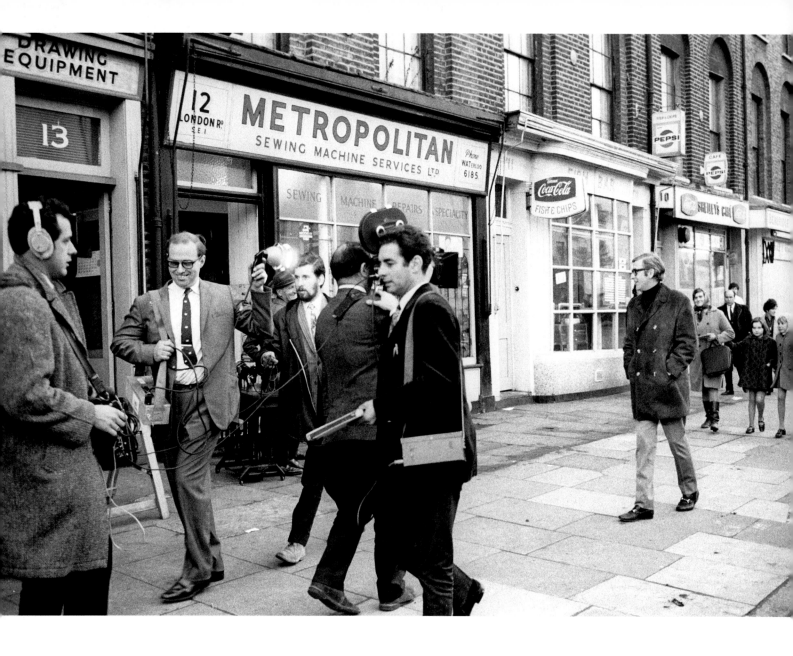

Michael Caine being filmed on location in the Elephant and Castle
area of London for the ITV documentary **CANDID CAINE**, 1969.

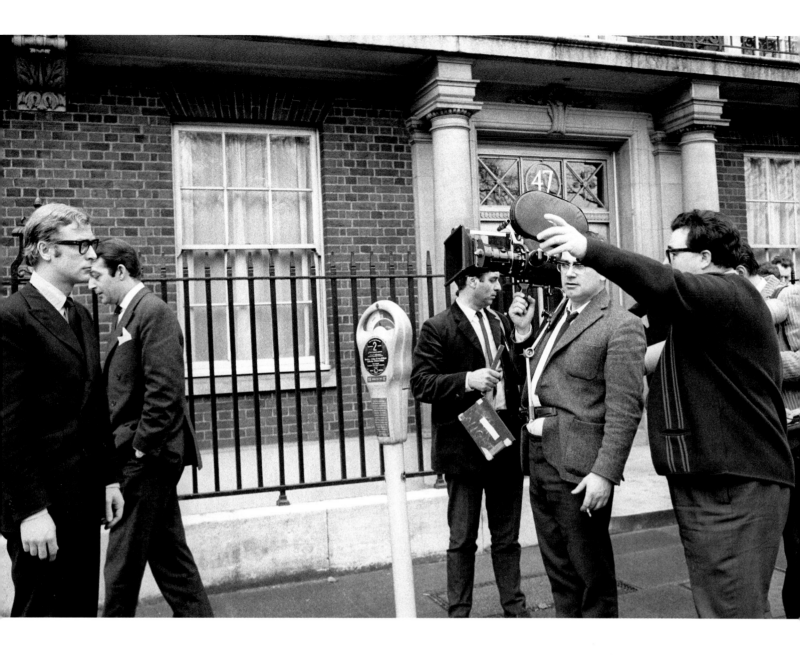

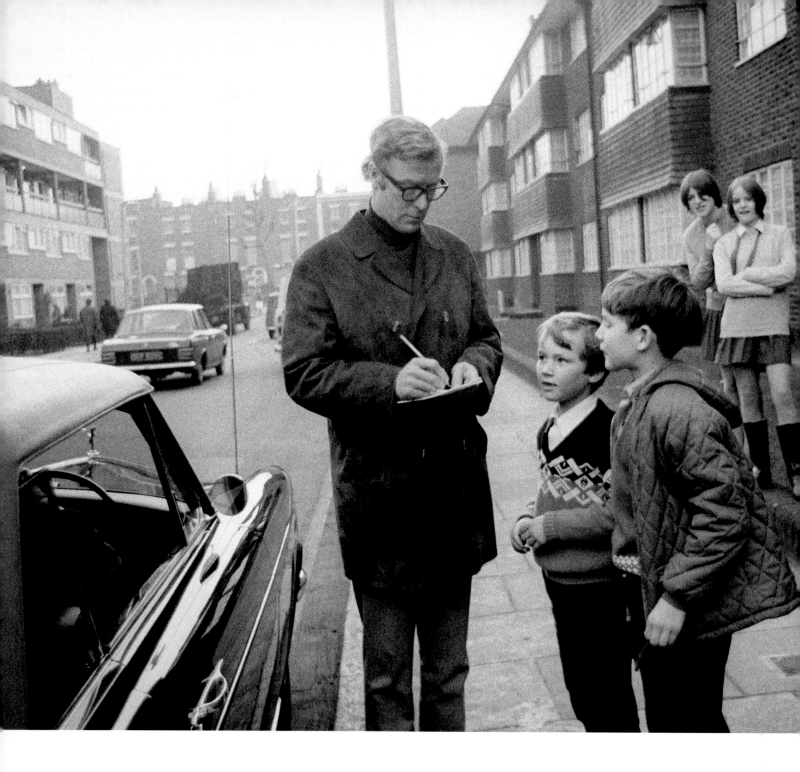

Above: Michael Caine signing autographs for children near the Elephant and Castle. A scene from the ITV documentary **CANDID CAINE**, 1969. *Opposite*: Home sweet home. Michael Caine visits Urlwin Street, Camberwell, London, where he once lived. Photographed for the ITV documentary **CANDID CAINE**, 1969.

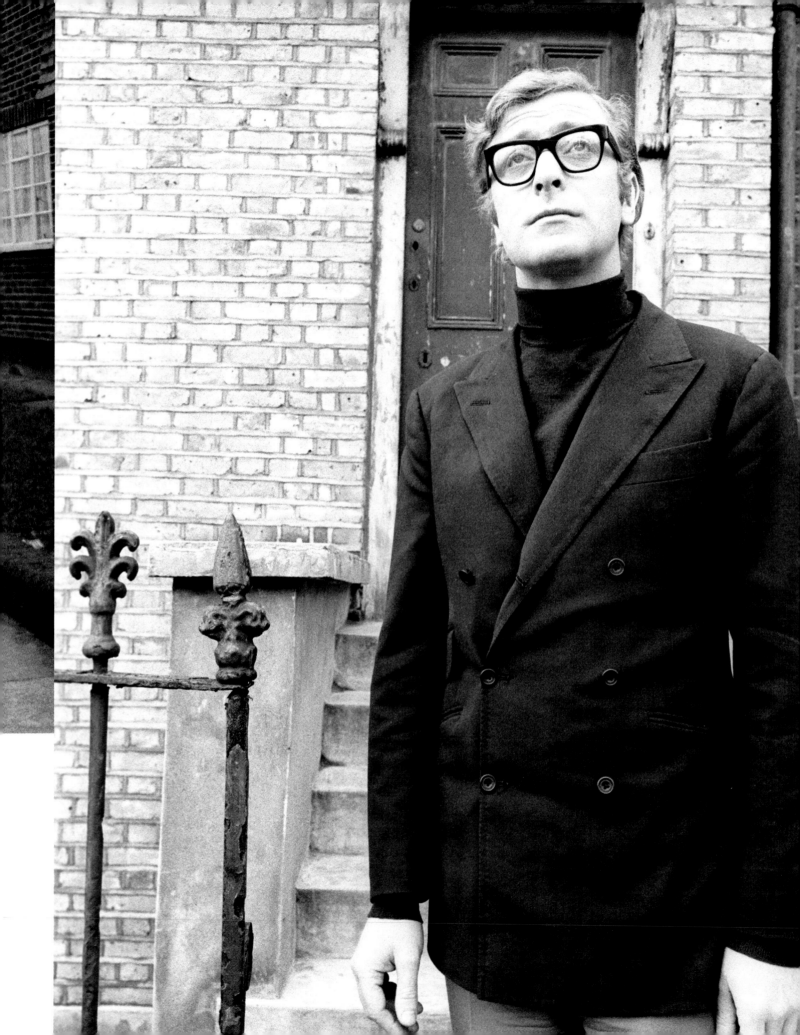

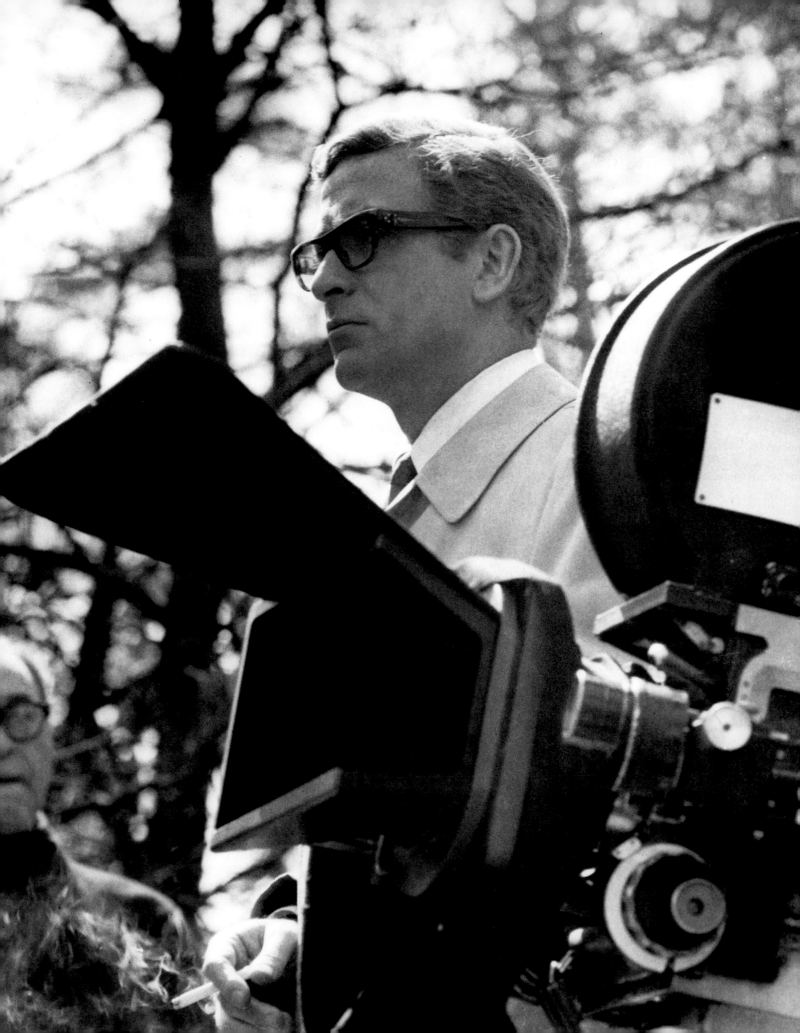

acknowledgements

A tip of the beret to: June Marsh for her infinite patience and help in getting this show on the road, Tony Nourmand for surfacing the good stuff from the photographic archives, Jack Cunningham for his computer wizardry and to Alison Elangasinghe for her in depth, out of sight editing.

Reel Art Press would like to thank the following friends and colleagues for their continual help and support: Bob Adelman, Stephen Atkinson, Ron Avery, Lisa Baker, Joseph Baldassare, Jonathan Bell, Daniel Bouteiller, Luisa Brassi, Joe Burtis, James Butcher, The Crew from the Island, Priya Elan, Christopher Frayling, Leslie Gardner, Richard Garvey, Marc Glanville, Richard Harris, Ron Harvey, Andy Howick, Beth Jacques, Andy and Maria Johnson, Dave Kent, Todd Lifft, Sara Lindström, Howard Mandelbaum, Ron Mandelbaum, June Marsh, Katherine Marshall, Rick Mayston, Phil Moad, Samira Kafala Noakes and Jake Noakes, Bruno Nouril and Ksenia Yachmetz Nouril, Hamid and Doris Nourmand, Sammy and Shaeda Nourmand, Joakim Olsson, Eric Rachlis, Steve Rose, Philip Shalam, Jonathan Stone, Caroline Theakstone, Darren Thomas and Jeff Wendt.

additional captions

p.3 'My name is Michael Caine...' p.5 Between takes on the movie **THE IPCRESS FILE**, 1965. p.6 Len Deighton, serious cook and author of **THE IPCRESS FILE**, teaches Caine how to break eggs with one hand. p.8 In the mid-1960s, Michael Caine was every optician's dream – he made wearing dark coloured heavy framed glasses look cool. p.11 Arriving in the USA. Caine once said, 'I wouldn't make an anti-American film. I'm one of the most pro-American foreigners I know. I love America and Americans.' p.12 It was hard work on the set of **THE IPCRESS FILE**, so Michael makes the crew a nice cup of tea. p.14 Turin, August 1968. Caine doing his best off-duty Charlie Croker impersonation. p.124 An actor prepares: Michael Caine, in the role of Harry Palmer, waits for the cameras to start filming another scene in the movie **FUNERAL IN BERLIN**, 1966.

photo credits

Cover Mirrorpix; p.2 Mirrorpix; p.5 Everett Collection; p.7 Everett Collection; p.8 Duffy/Getty Images; p.11 Rex Features; p.12 ITV Global / The Kobal Collection; p.14/15 Mondadori Portfolio via Getty Images; p.16/17 Rex Features; p.18 Photofest; p.19 Rex Features; p.20/21 Mirrorpix; p.22 Harry Dempster/Express/Getty Images; p.23/24/25/26/27 Mirrorpix; p.28/29 Stephan C Archetti/Getty Images; p.30 Everett Collection; p.31 The Kobal Collection; p.33 BFI; p.34/35 The Kobal Collection; p.36 Photofest; p.37/38 The Kobal Collection; p.39 Photofest; p.40 BFI; p.41 Rex Features; p.42 Mirrorpix; p.43 Everett Collection; p.44 The Kobal Collection; p.45 RDA/Hulton Archive/Getty Images; p.47 Rex Features; p.48/49/50 Collection T.C.D.; p.51 BFI; p.52/53 Duffy/Getty Images; p.54 Collection T.C.D.; p.55 Getty Images; p.56/57 Collection T.C.D.; p.58/59 Collection T.C.D.; p.60 Rex Features; p.61 BFI; p.63 The Kobal Collection; p.64 BFI; p.65 Collection T.C.D.; p.66/67 The Kobal Collection; p.68 Photofest; p.69 Collection T.C.D.; p.70 BFI; p.71 Collection T.C.D.; p.72 Reg Lancaster/Express/Getty Images; p.73 Collection T.C.D.; p.74 Photofest; p.75 Collection T.C.D.; p.77 Collection T.C.D.; p.78 BFI; p.79 Everett Collection; p.80/81 Mirrorpix; p.82/83 © Douglas Kirkland/Corbis; p.84 Everett Collection; p.85 Terry O'Neill/Getty Images; p.86/87 © Raymond Depardon/Magnum Photos; p.89/90/91 The Kobal Collection; p.92 Collection T.C.D.; p.93 BFI; p.94/95 The Kobal Collection; p.96 Collection T.C.D.; p.97/ 98/99/100/101/102 The Kobal Collection; p.103 Collection T.C.D.; p.104 Archive Photos/Getty Images; p.105 Photofest; p.106/107 Mirrorpix; p.108 (top left and top right) Mirrorpix; p.108 (bottom left and bottom right) Getty Images; p.109/110/111 Mirrorpix; p.112 Getty Images; p.113 BFI; p.114 Everett Collection; p.115 Photofest; p.116 (left) Getty Images; p.116 (right) Rex Features; p.117 Getty Images; p.118/119/120/121/122/123 Rex Features; p.124 Getty Images; p.127 Mirrorpix; Back Cover Mirrorpix.

bibliography

Caine, Michael, *Michael Caine, The Autobiography – The Elephant to Hollywood* (London 2011); Crawley, Tony, *Chambers Film Quotes* (Edinburgh, 1991); Hewitt, Paolo, *The Sharper Word: A Mod Anthology* (London, 2002); *The Italian Job, 40th Anniversary Edition* (DVD, 2009). Special thanks to Hazel Collinson, wife of the late Peter Collinson, director of *The Italian Job*; Pym, John, *Time Out Film Guide* (London 2010); Rose, Simon, *Classic Film Guide* (London, 1995); Smith, Emily, *The Michael Caine Handbook: Everything You Need to Know About Michael Caine* (Australia, 2012).

index

graham marsh

GRAHAM MARSH is an art director, illustrator and writer. He has written and art directed many groundbreaking visual books, including **THE COVER ART OF BLUE NOTE RECORDS, VOLUMES I AND II, EAST COASTING** and **CALIFORNIA COOL**. He co-authored and art directed **DENIM: FROM COWBOYS TO CATWALKS** and a best-selling series of books with Tony Nourmand on movie posters. His most recent projects include **THE IVY LOOK** and an illustrated children's book, **MAX AND THE LOST NOTE**. Graham is the art director of numerous Reel Art Press publications, including the critically acclaimed **THE RAT PACK, THE KENNEDYS: PHOTOGRAPHS BY MARK SHAW** and **HOLLYWOOD AND THE IVY LOOK** (which he also authored). Graham's illustrations have appeared in magazines, newspapers and on many CD and album covers. He has contributed to several publications including **COUNTRY LIFE** and **FINANCIAL TIMES**. He lives in Greenwich, south east London.

tony nourmand

TONY NOURMAND is founder of **REEL ART PRESS** and editor of all **R|A|P** publications, including the critically acclaimed **THE RAT PACK, HOLLYWOOD AND THE IVY LOOK** and **THE KENNEDYS: PHOTOGRAPH BY MARK SHAW**. Tony has also authored a further sixteen books on entertainment-related imagery, including the worldwide bestsellers, **JAMES BOND MOVIE POSTERS, AUDREY HEPBURN: THE PARAMOUNT YEAR** and a series of books on movie poster art by decade and by genre.

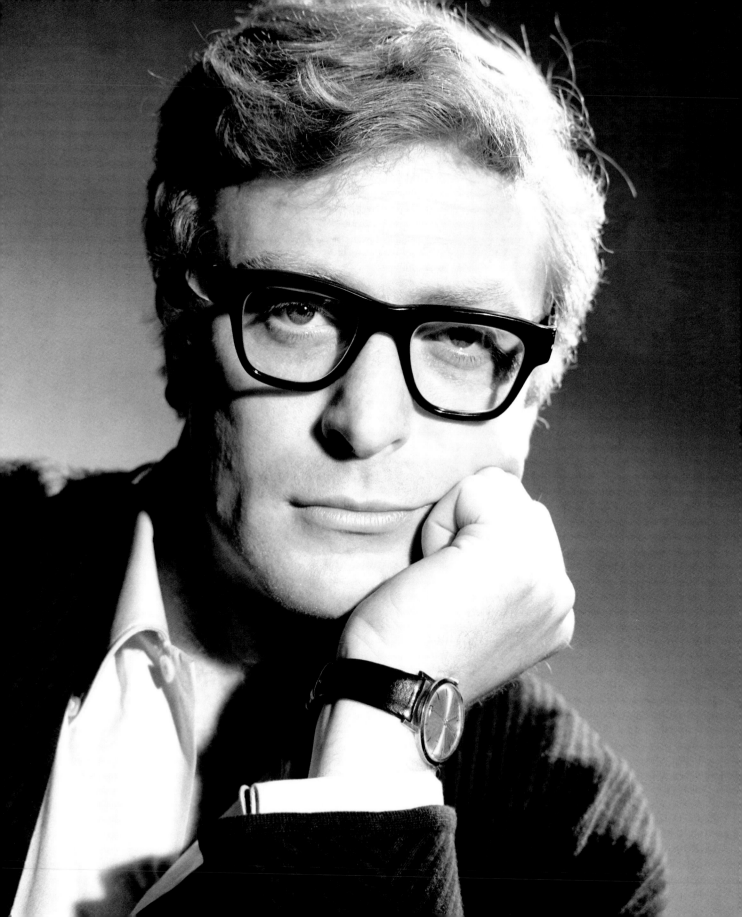

SID AVERY

the art of the hollywood snapshot

U.S. OFF TO BAD GOLF START

By MAURICE HART

No Luck For England Here..

..But No Doubt About This

IN-A-HURRY SURREY SET FOR VICTORY

By DOUG IBBOTSON

TEST: LAT